The Marvelous Mandala Coloring Book

Book 1

Introduction:

Introducing the very next series of Arredondoart books! This series is a more simple and fun way to color. The mandalas in this book are not as complex as the other series but still are very detailed! Relax and color these mandalas with a multitude of colors! In this book, there are different and unique mandala designs for coloring fun! Unlike the last book, that had a little under 50 drawings, this one has 100 different and unique drawings for the most coloring fun! Push yourself creatively or just relax and color some beautiful designs! Happy coloring!

- Christopher Arredondo/Arredondoart

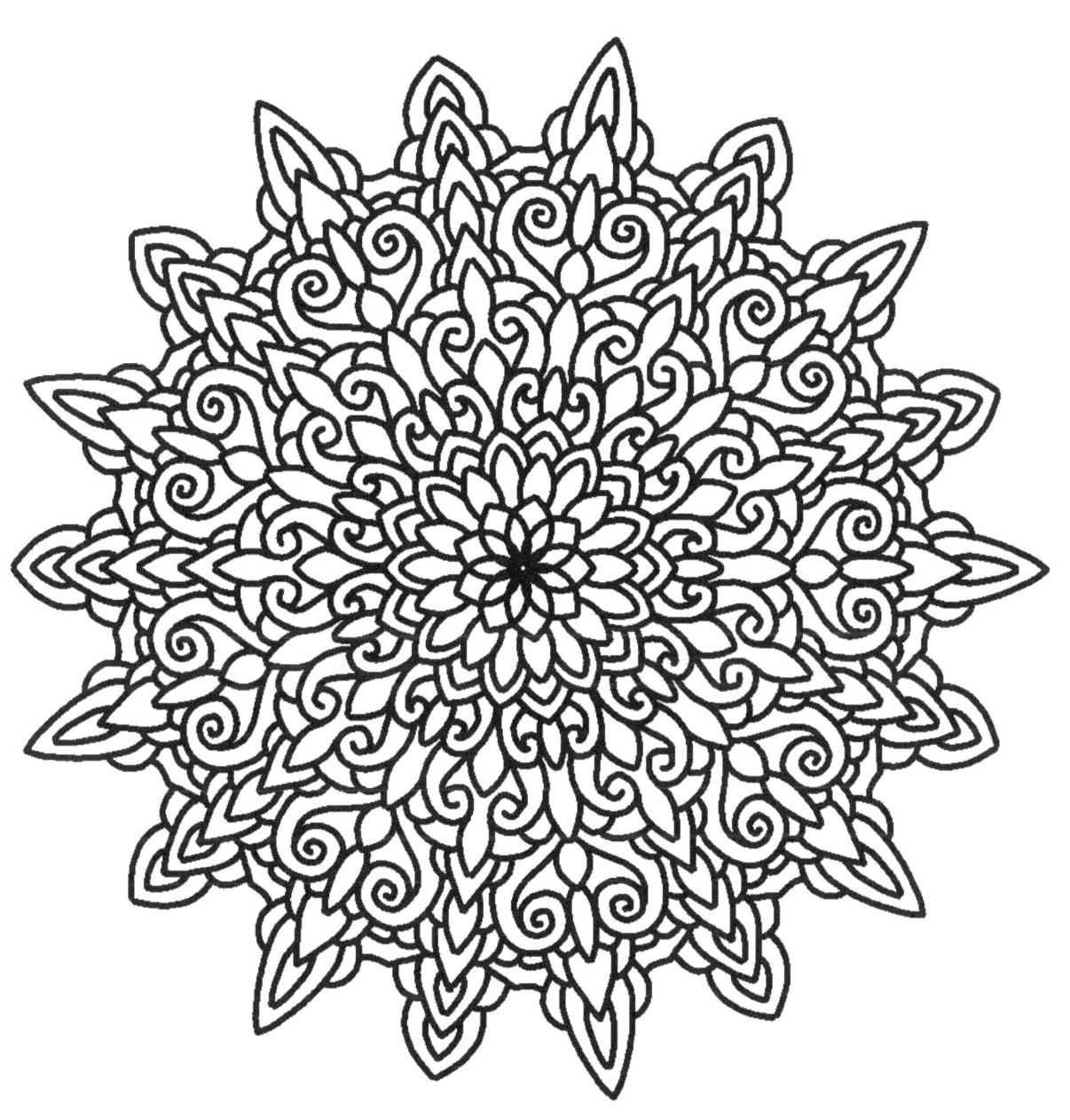

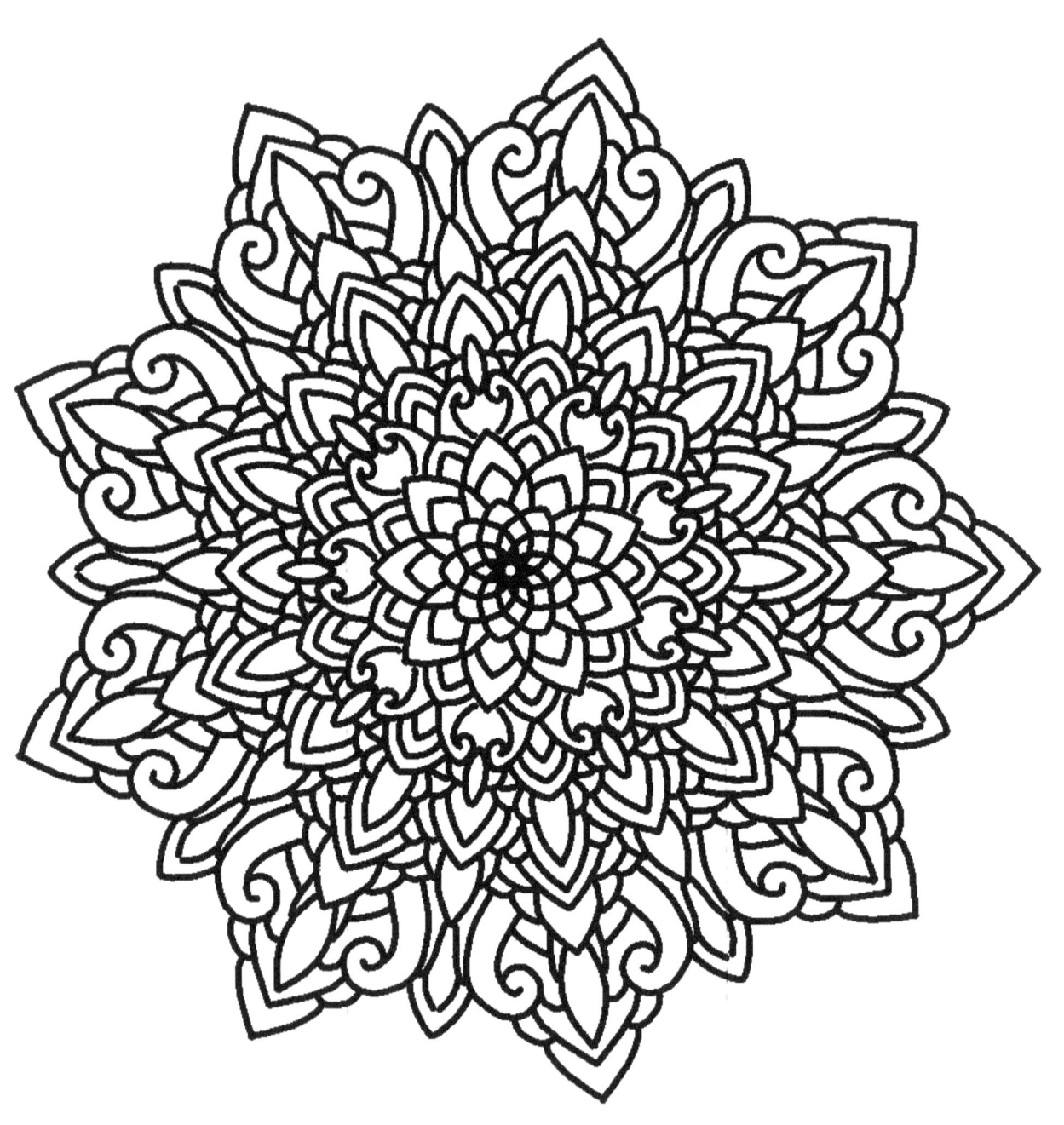

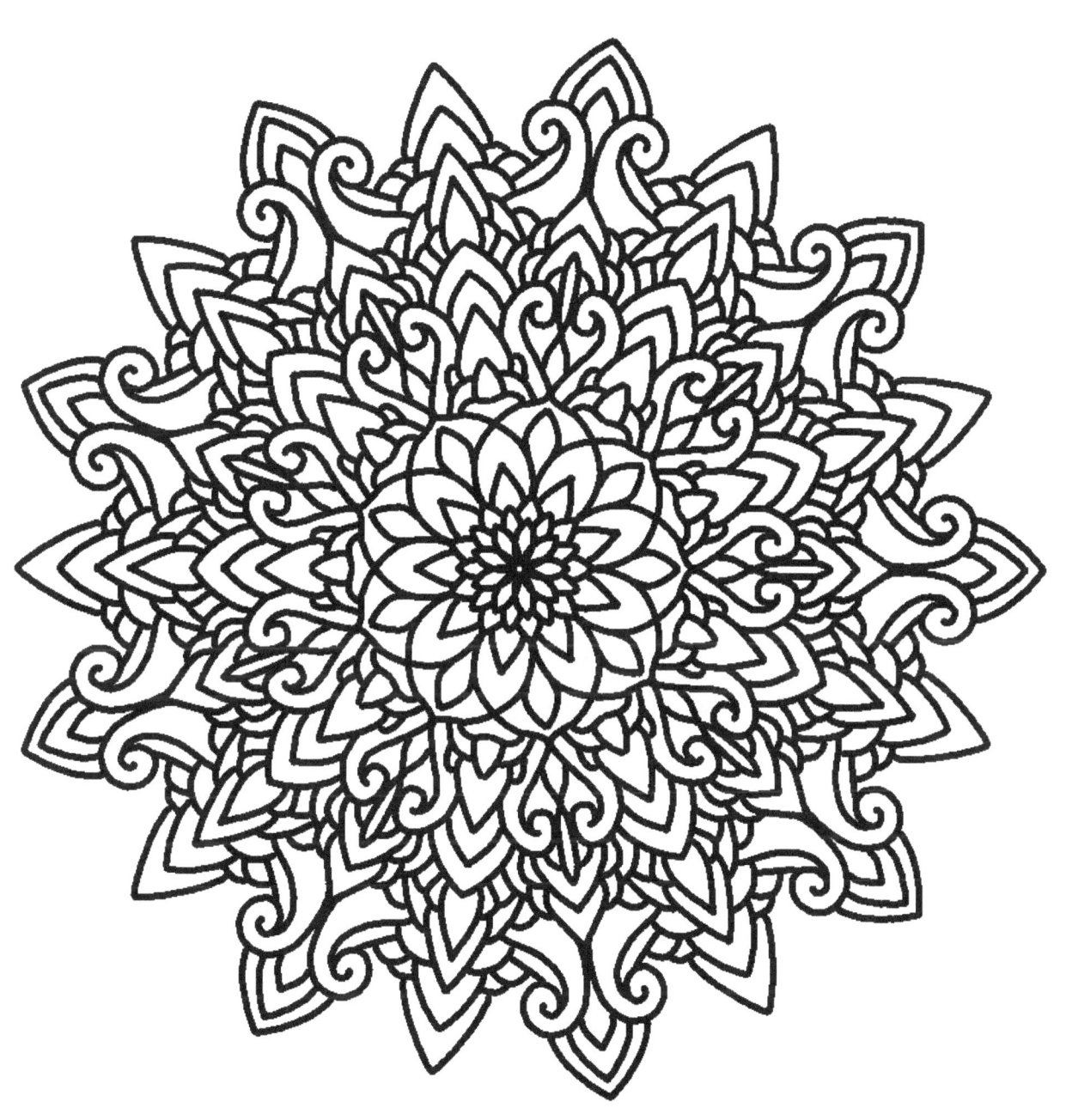

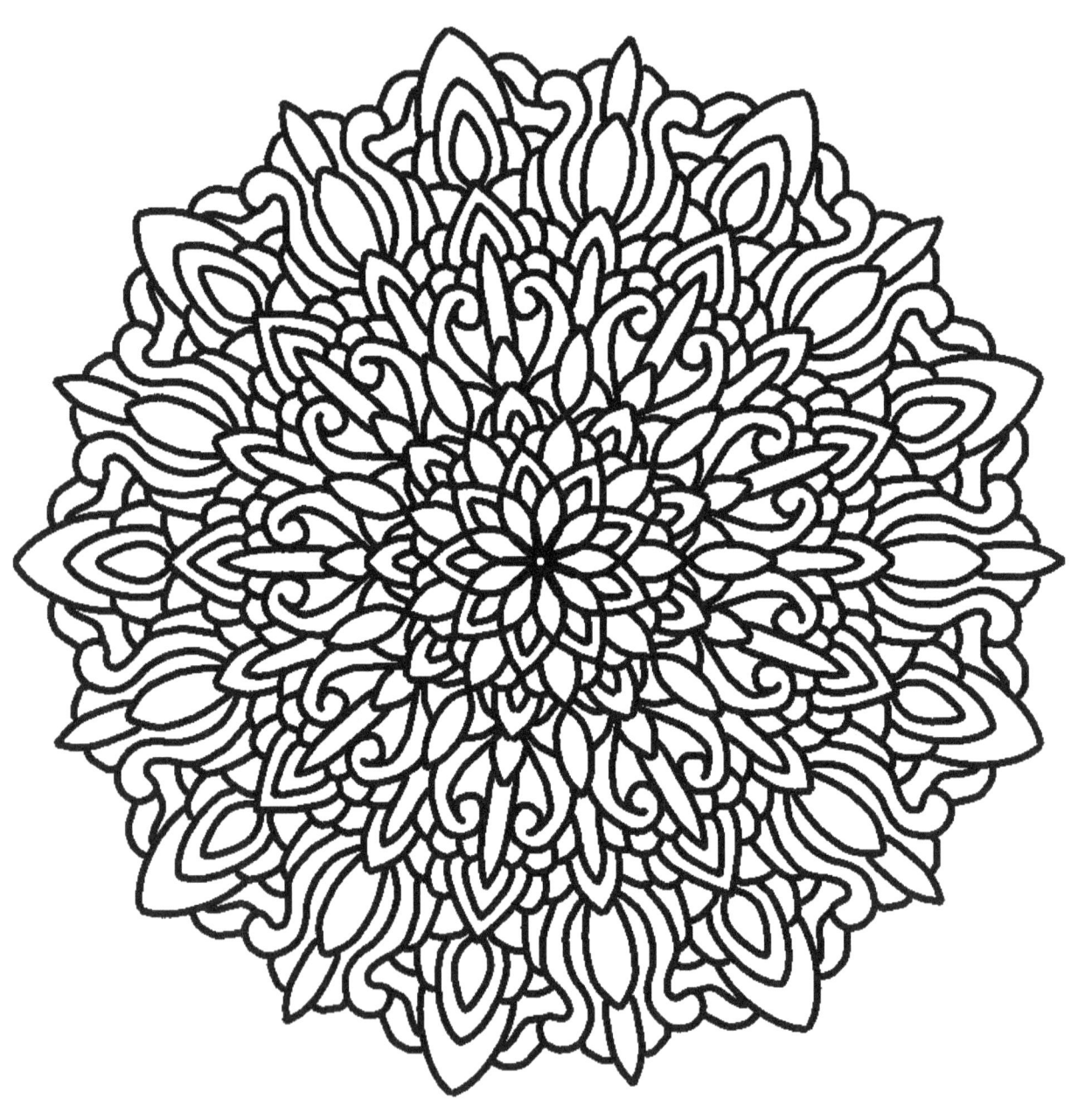

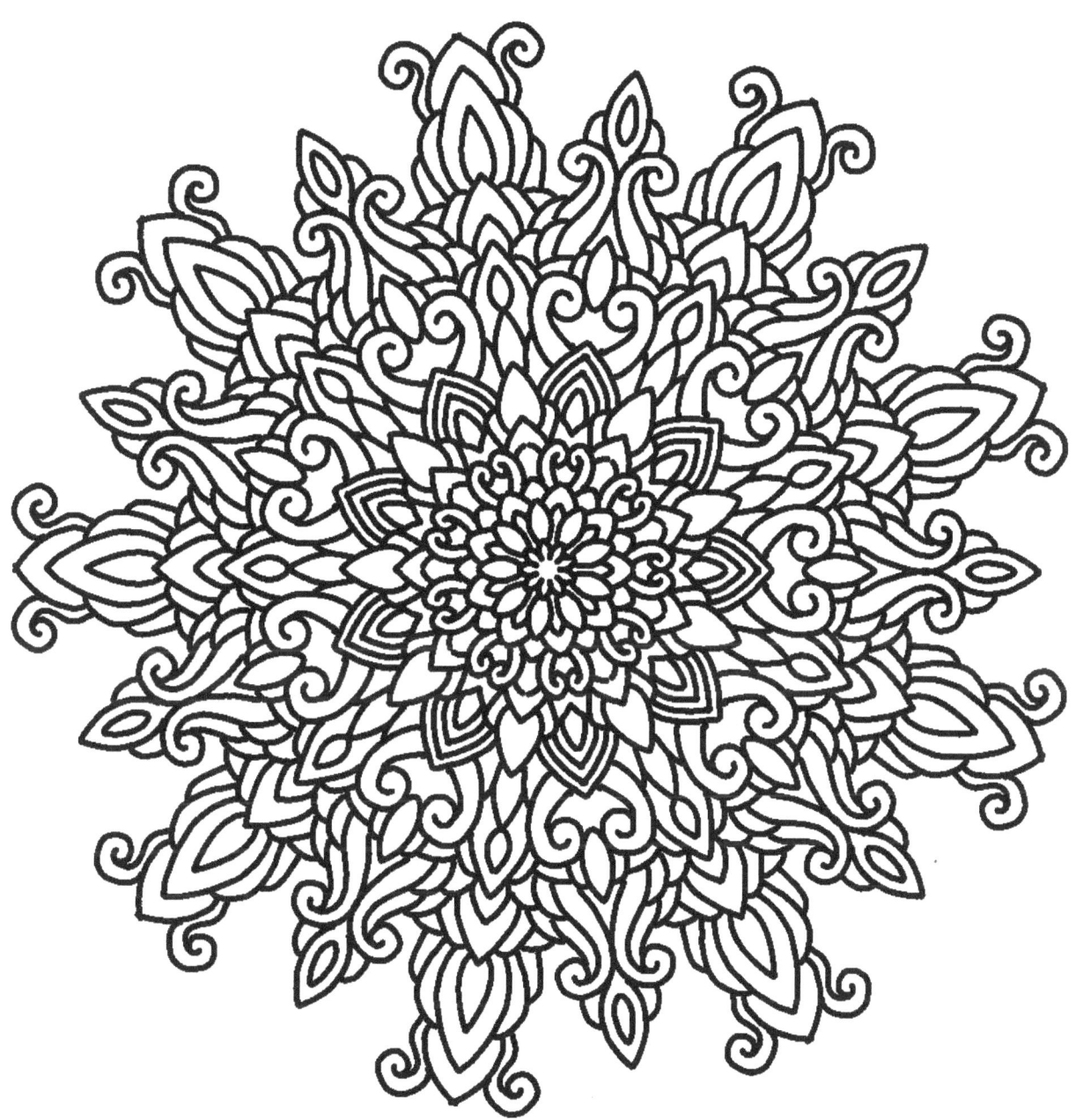

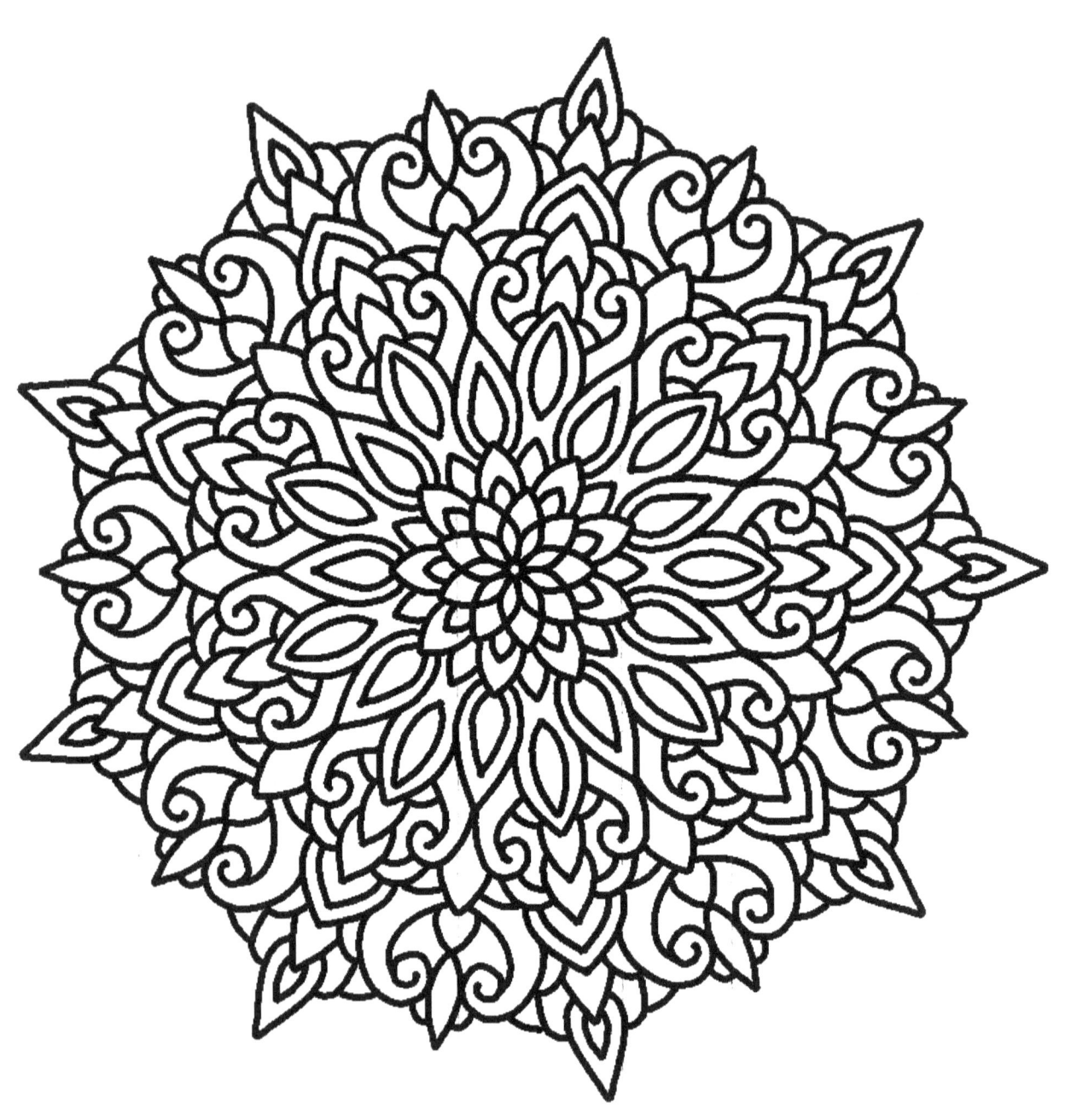

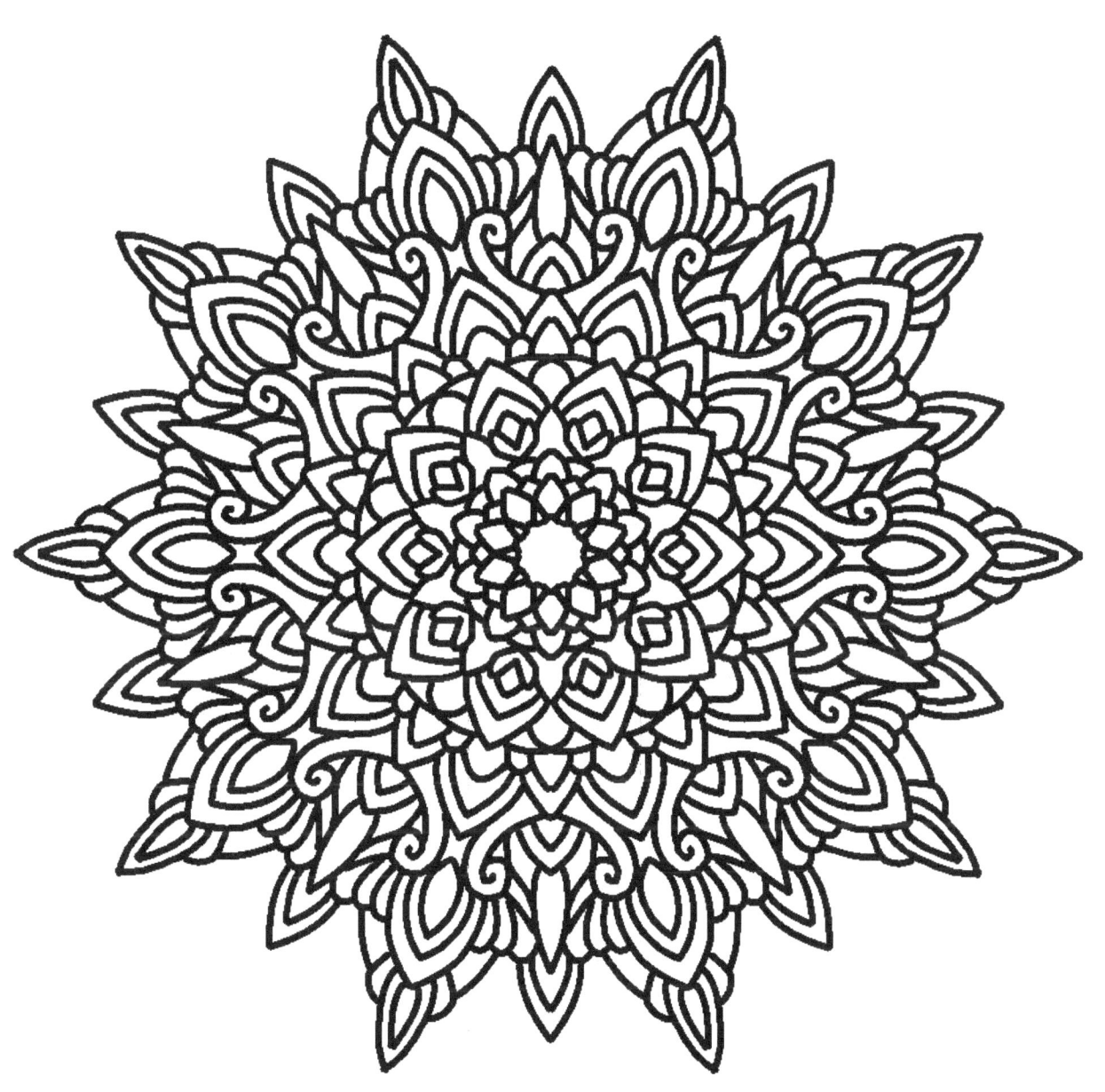

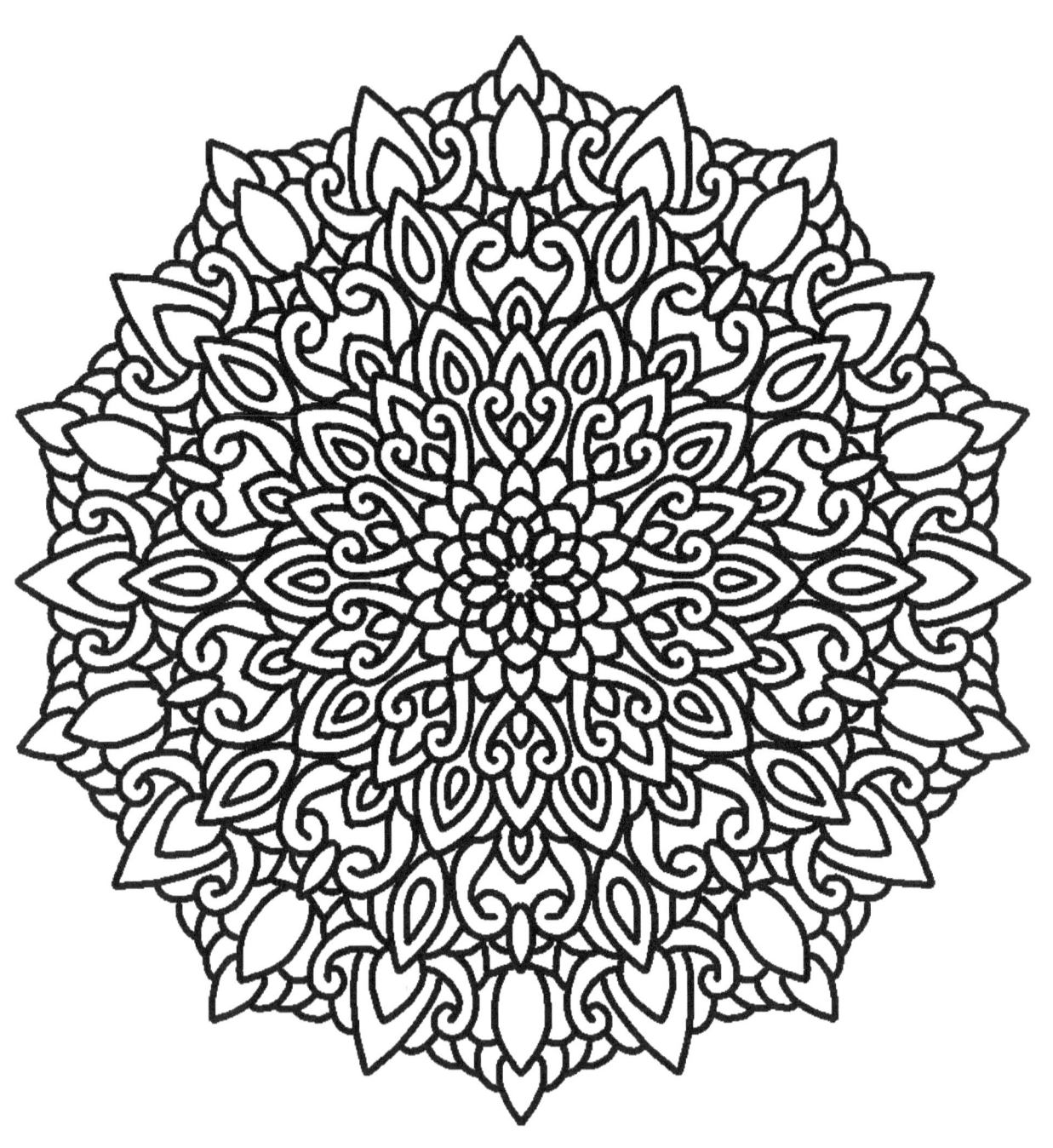

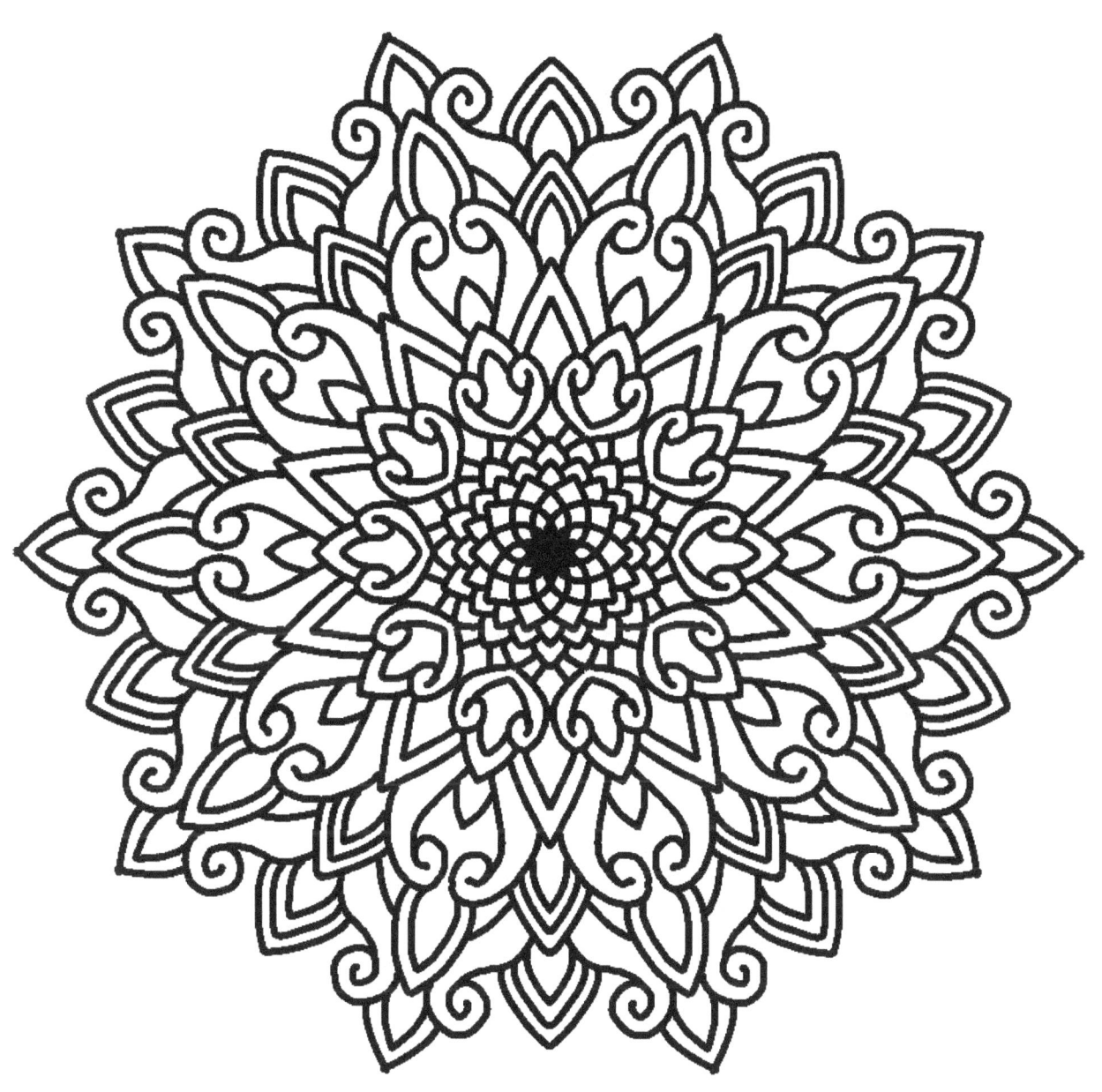

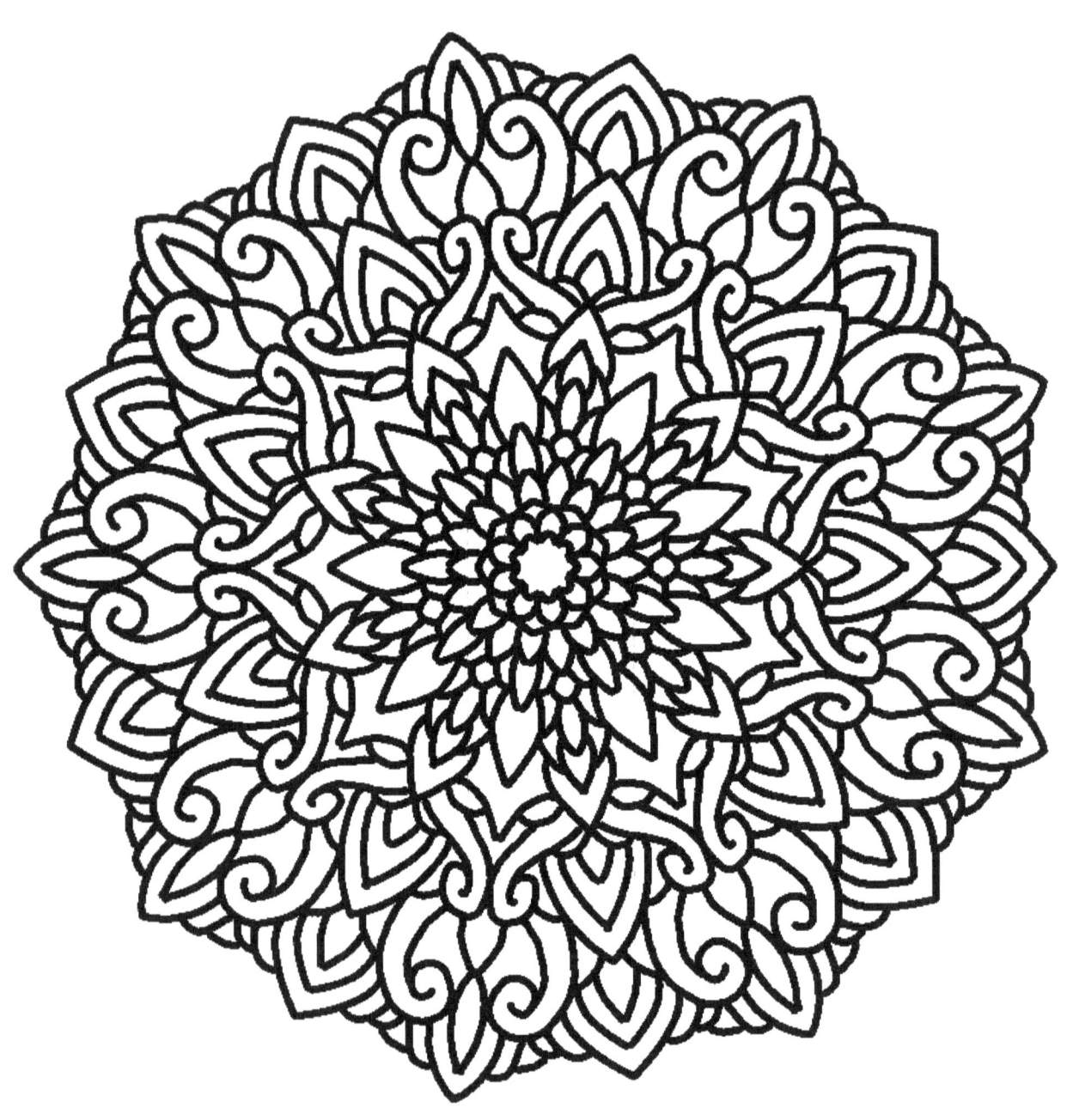

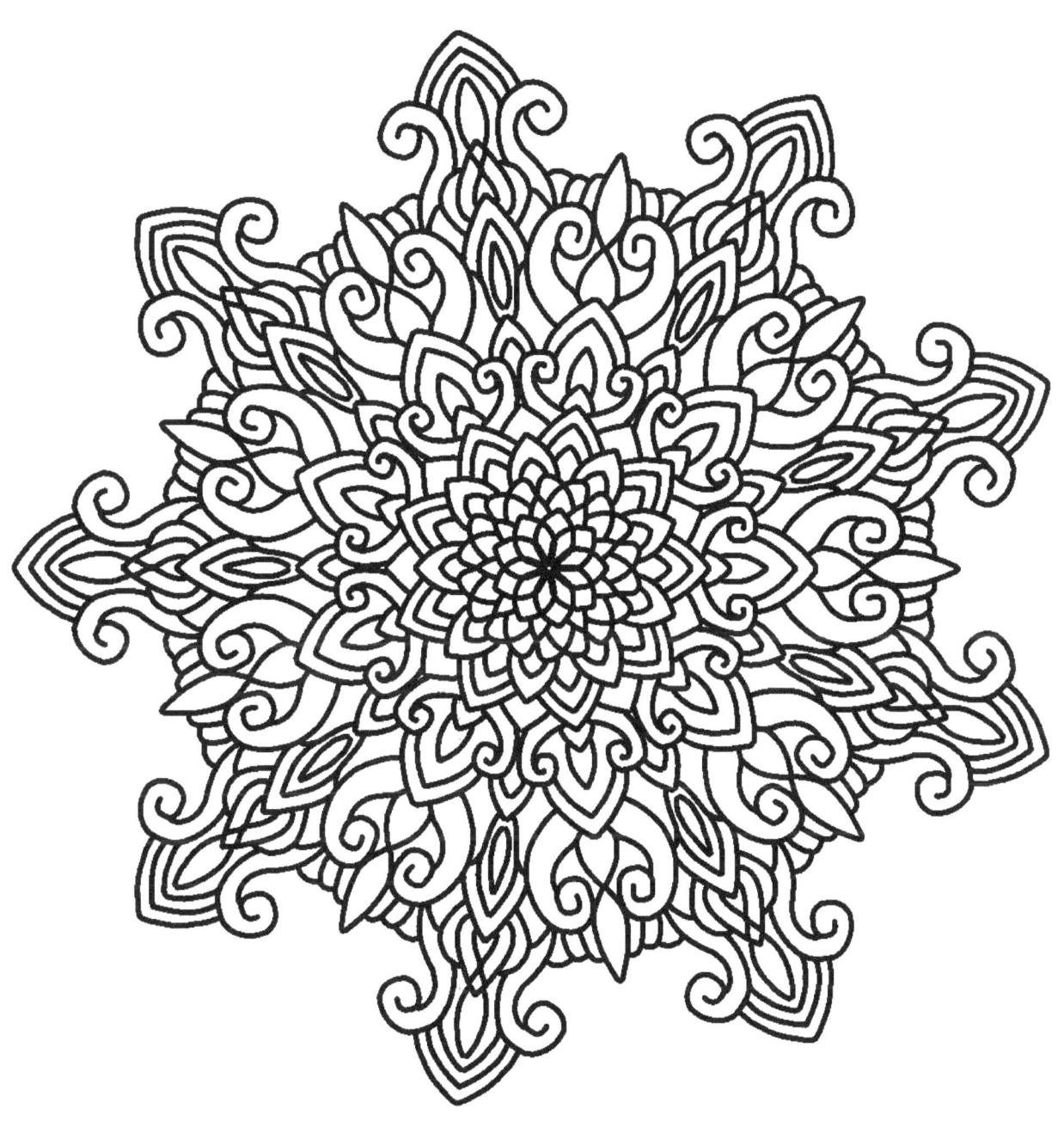

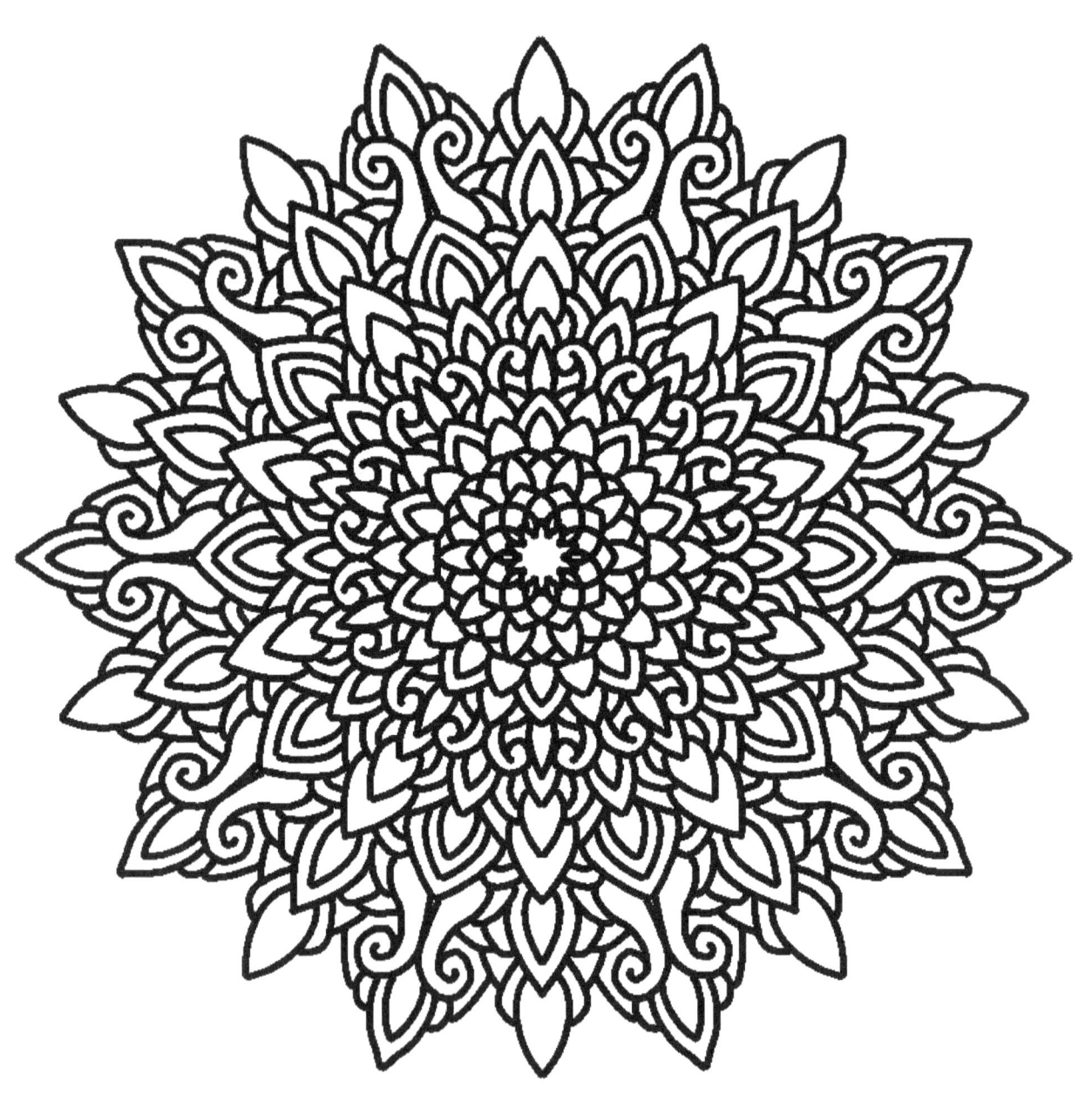

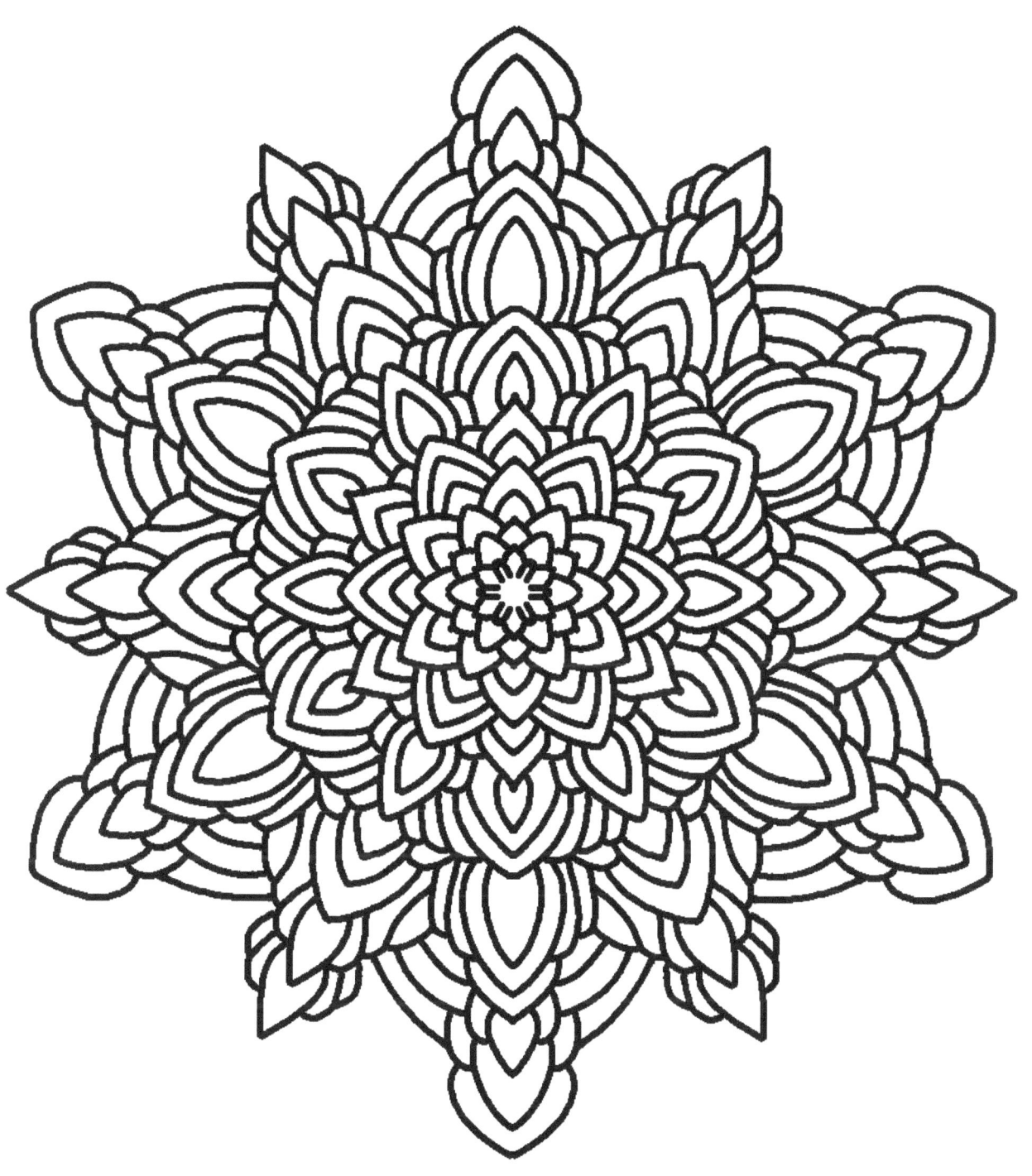

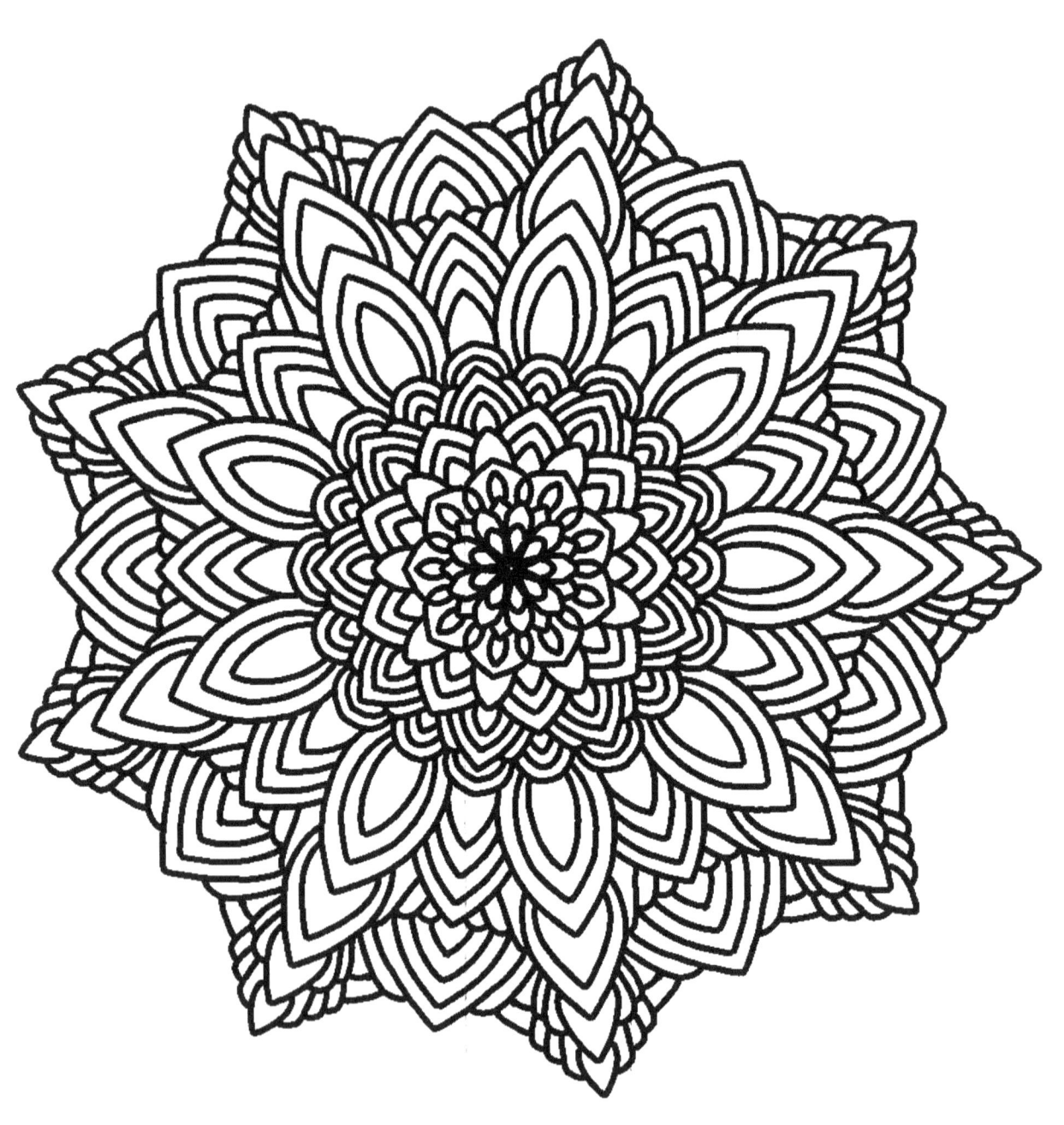

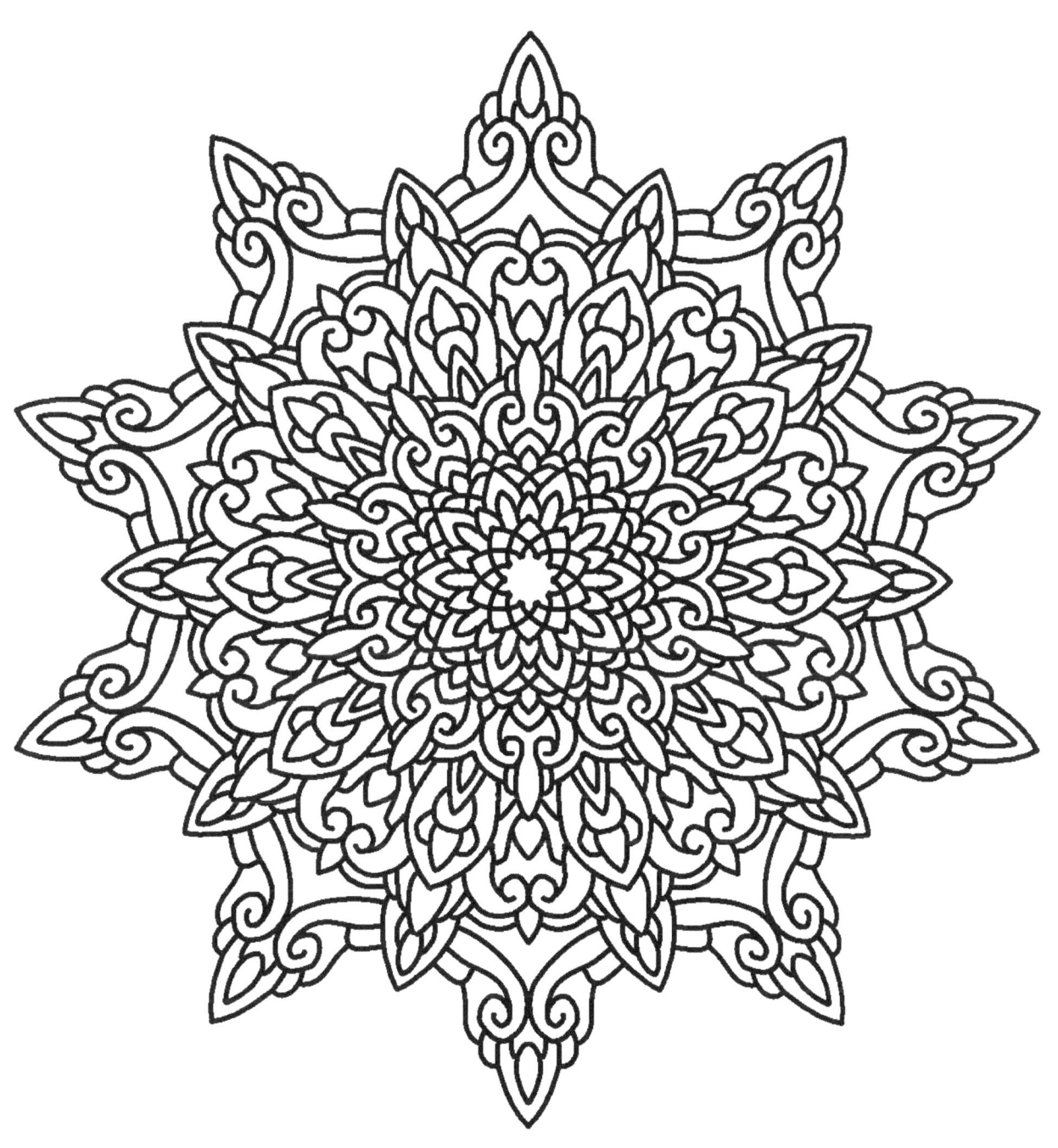

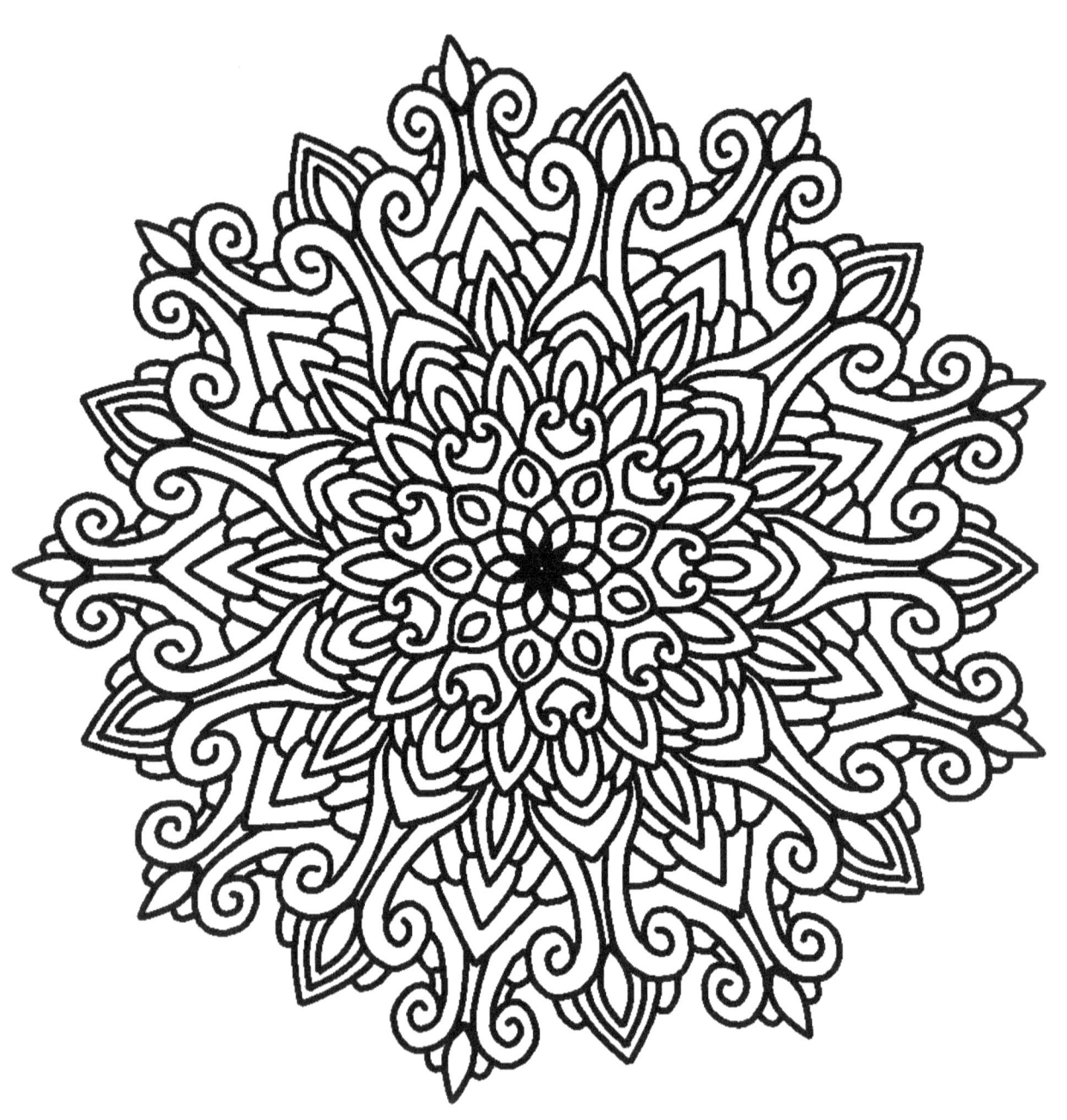

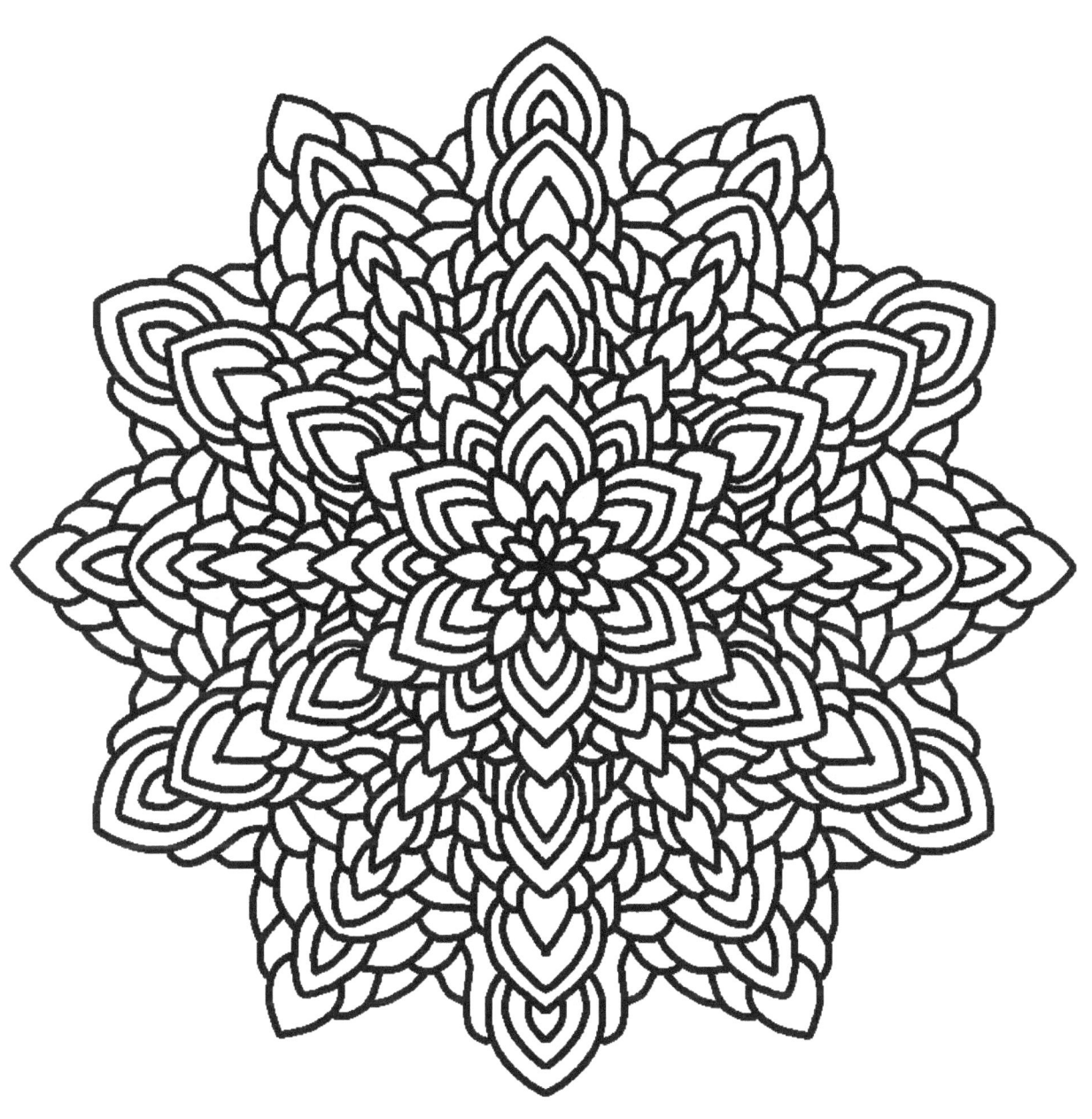

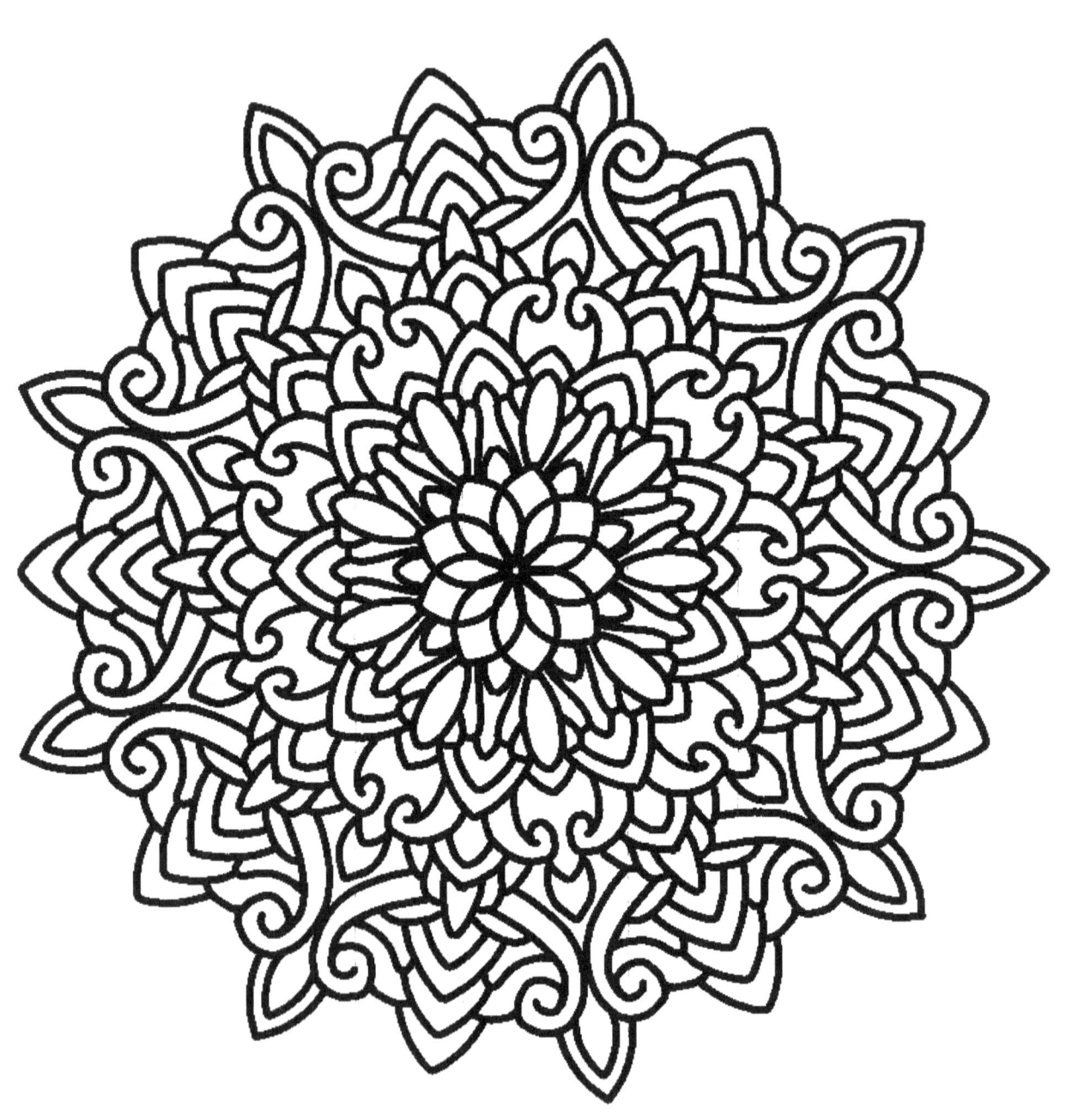

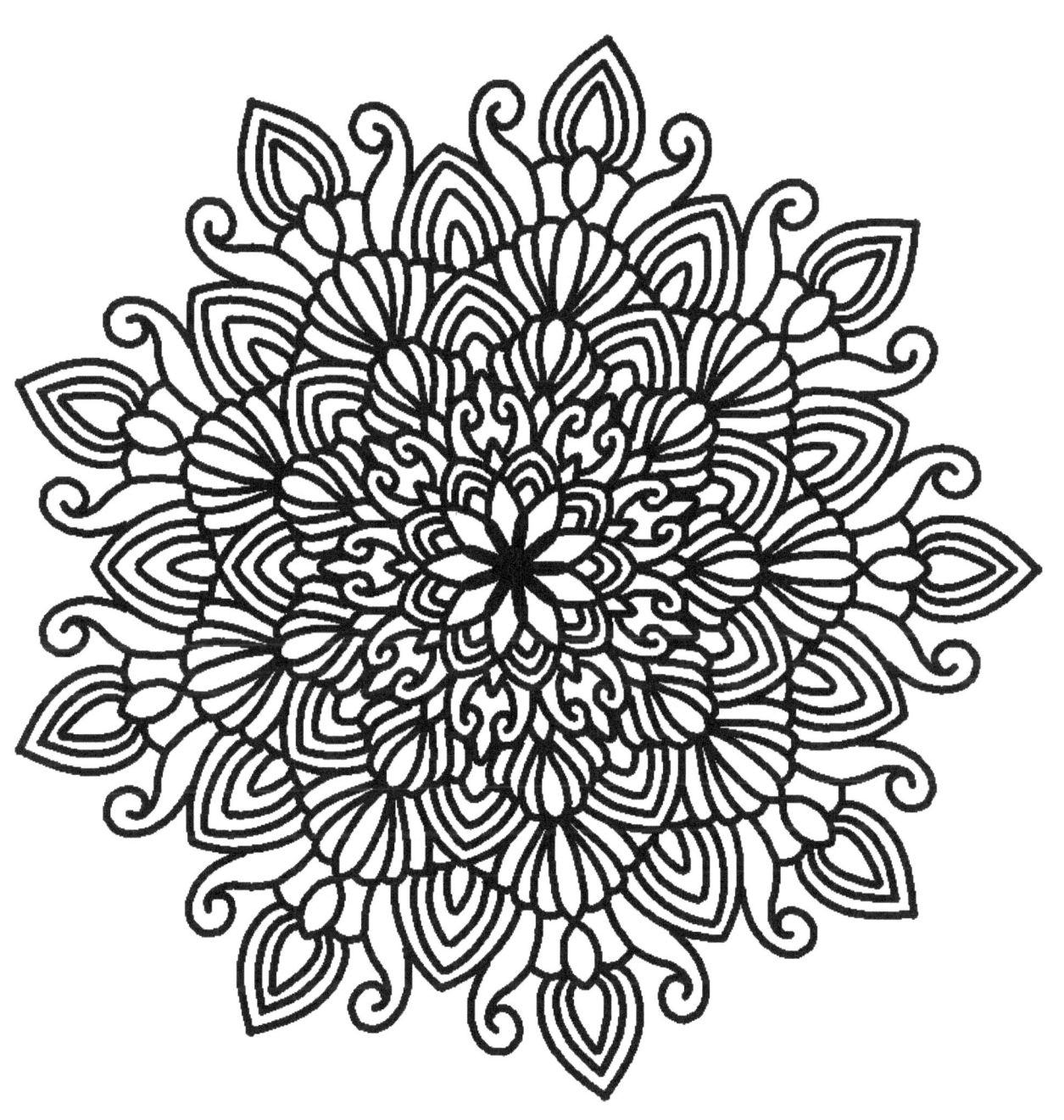

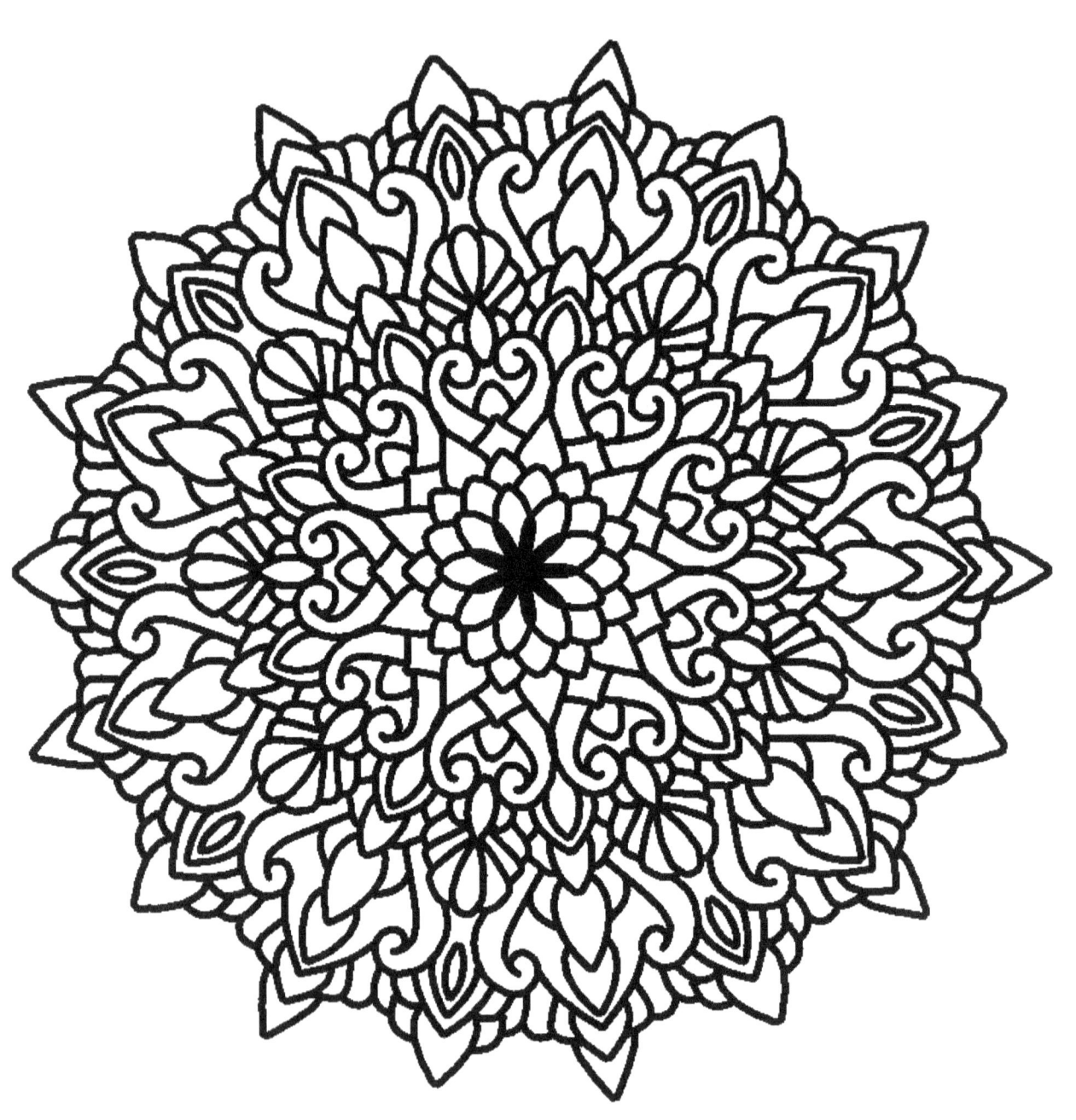

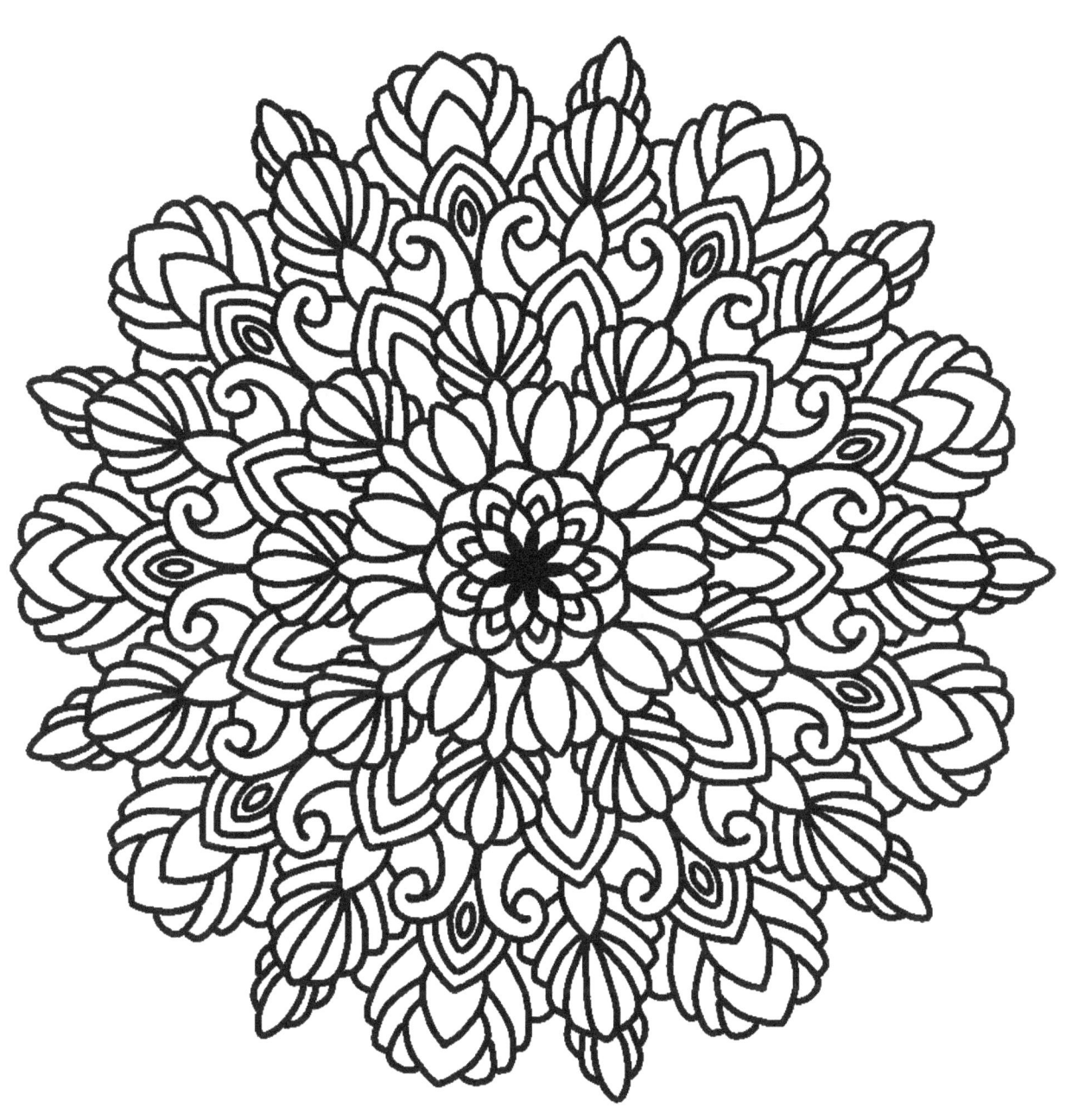

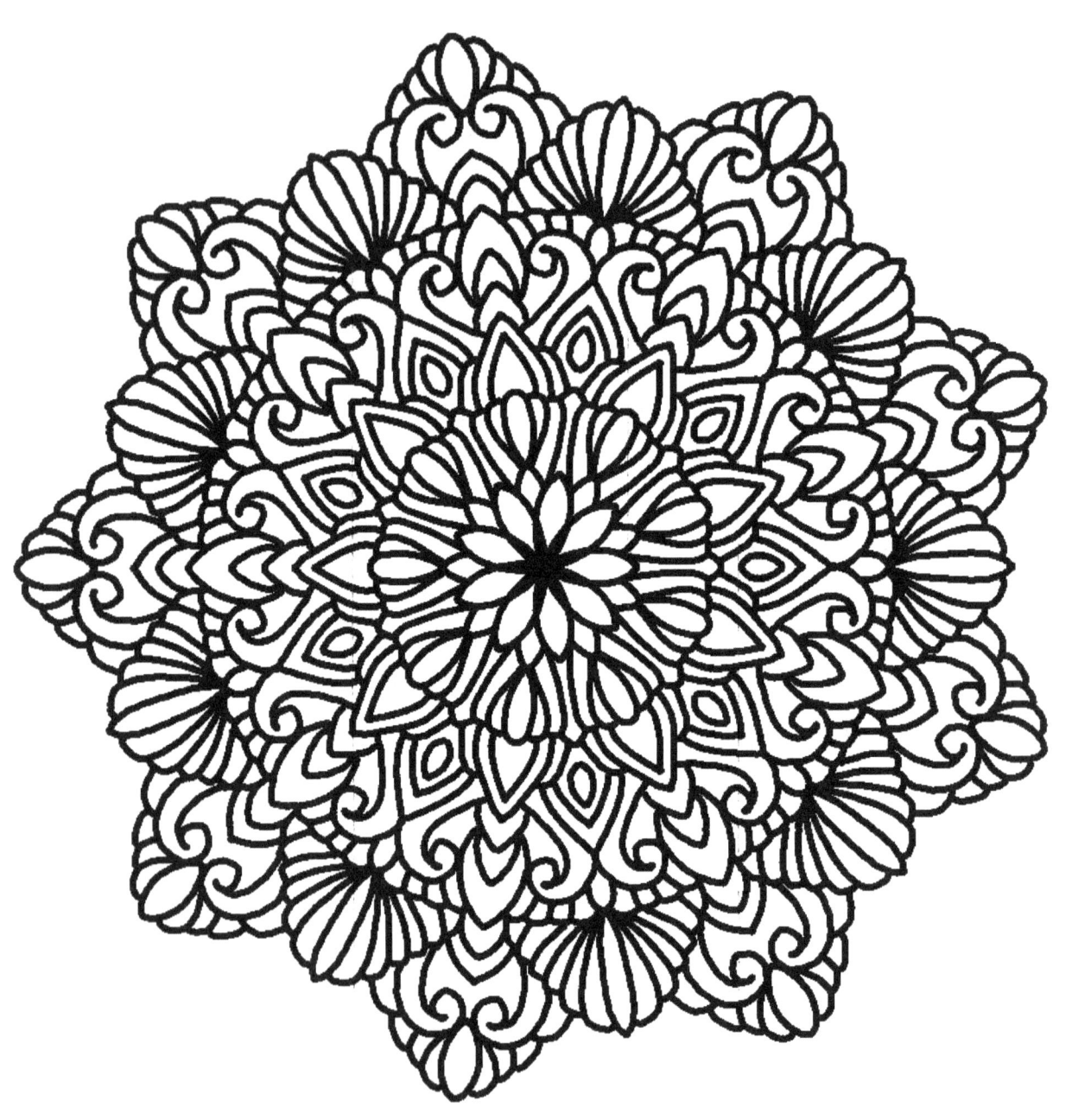

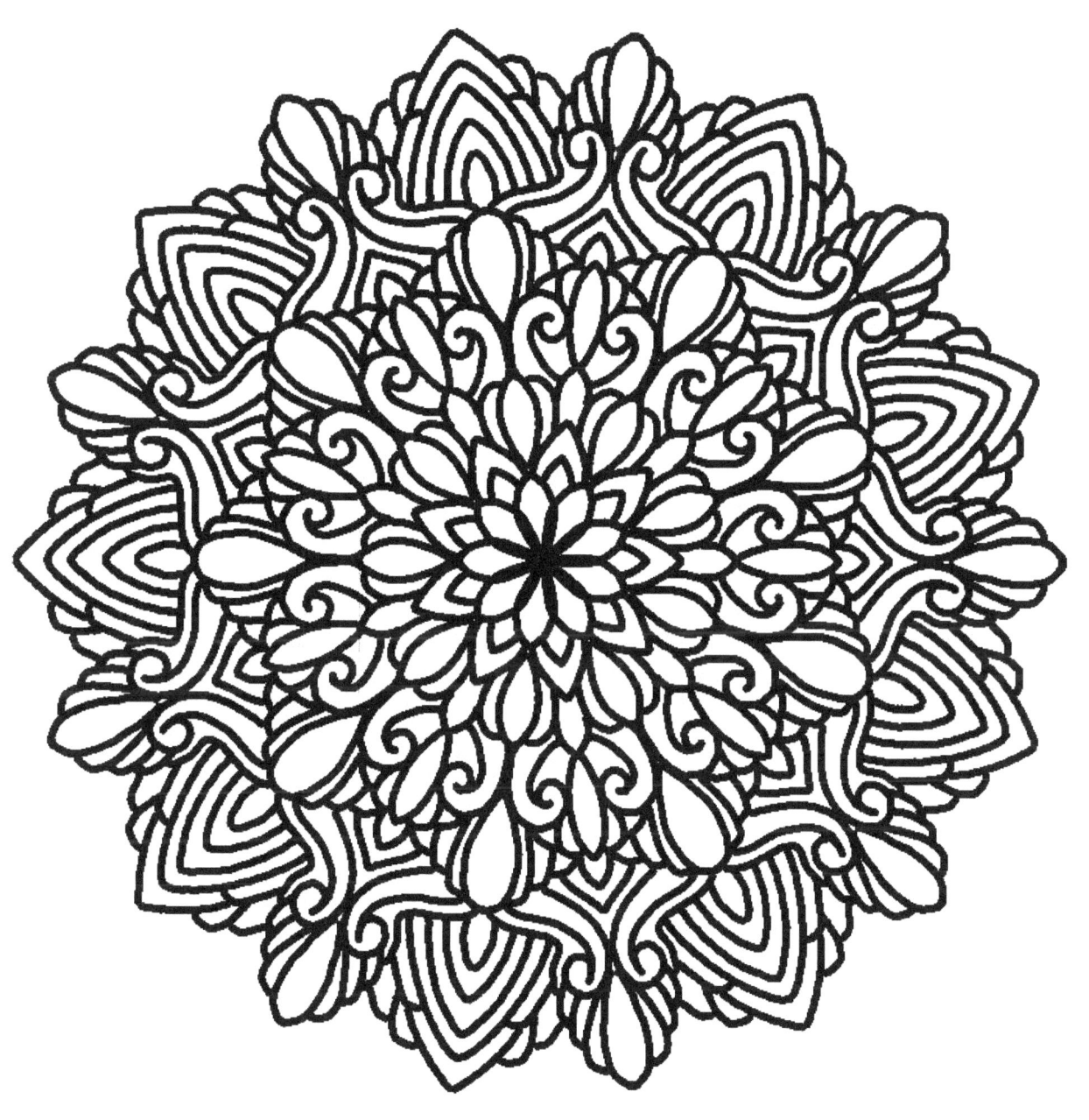

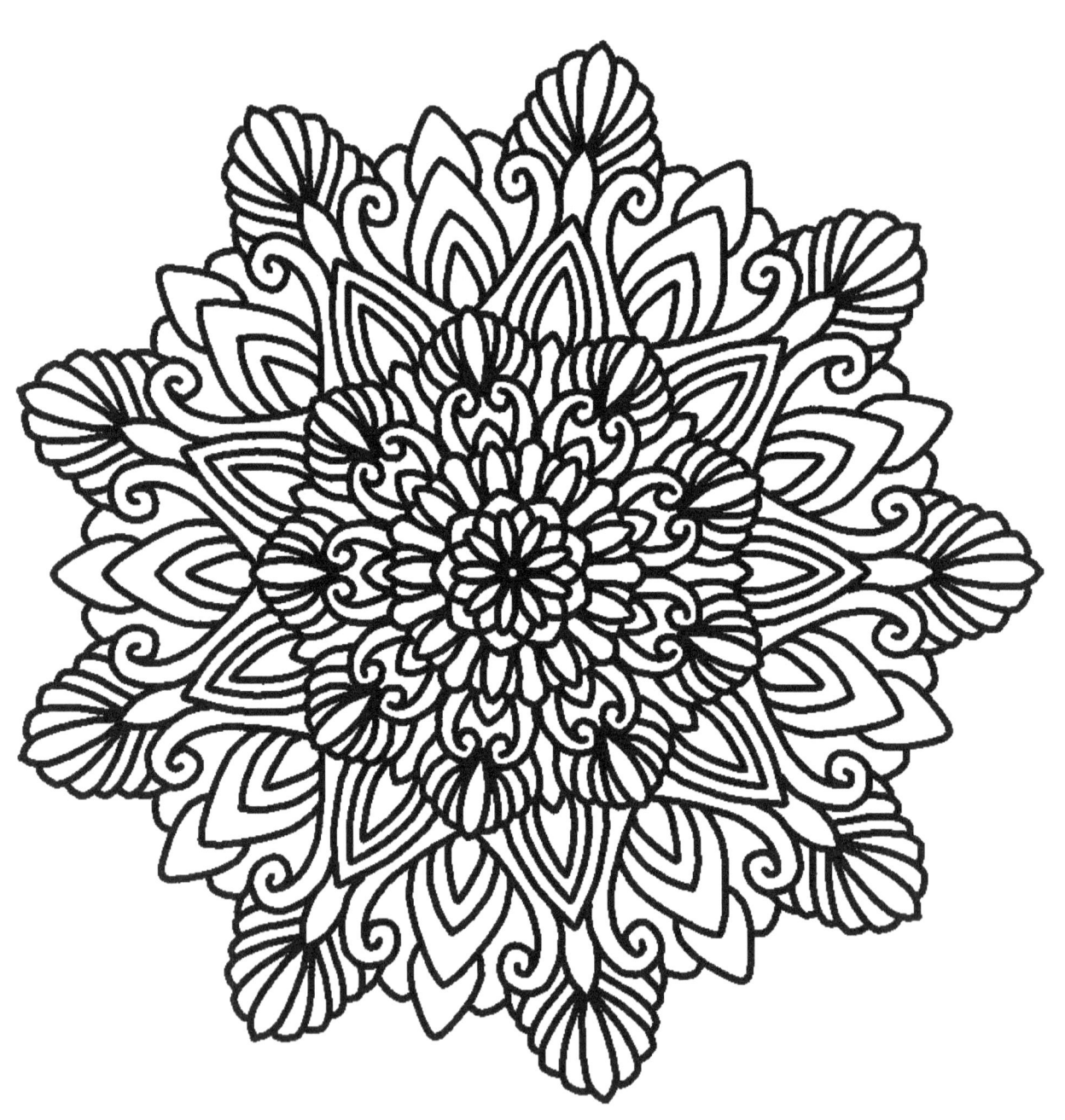

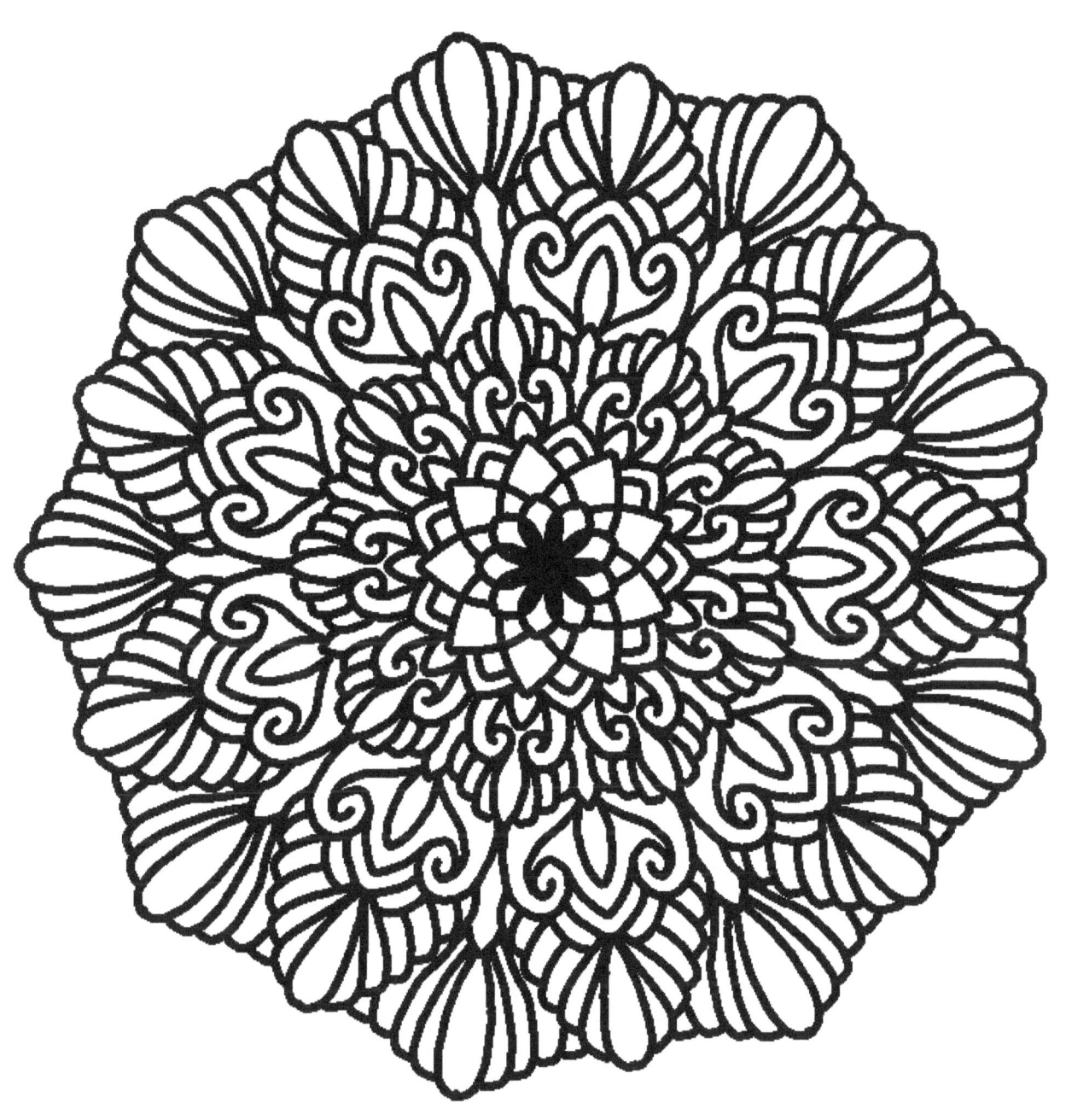

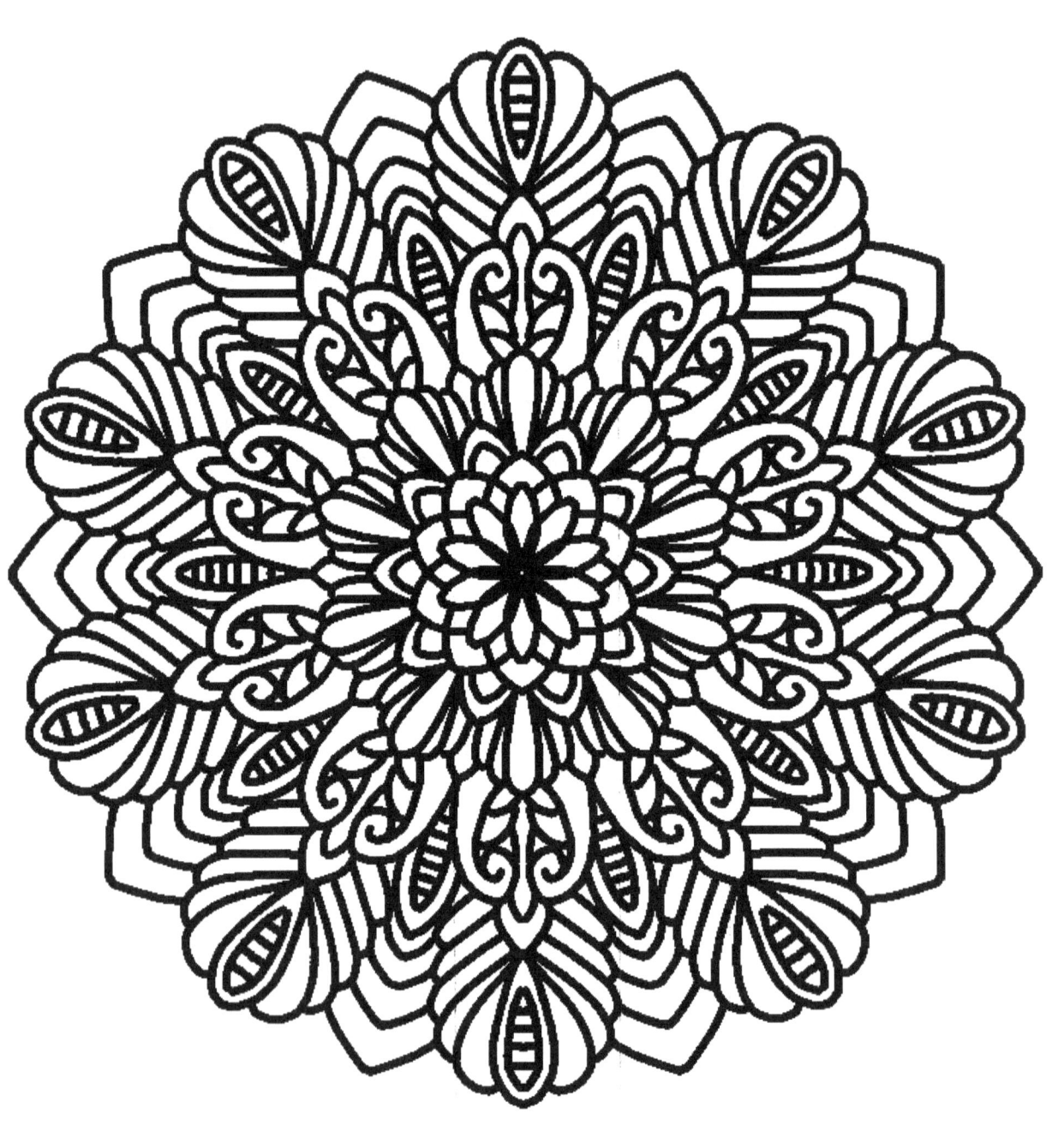

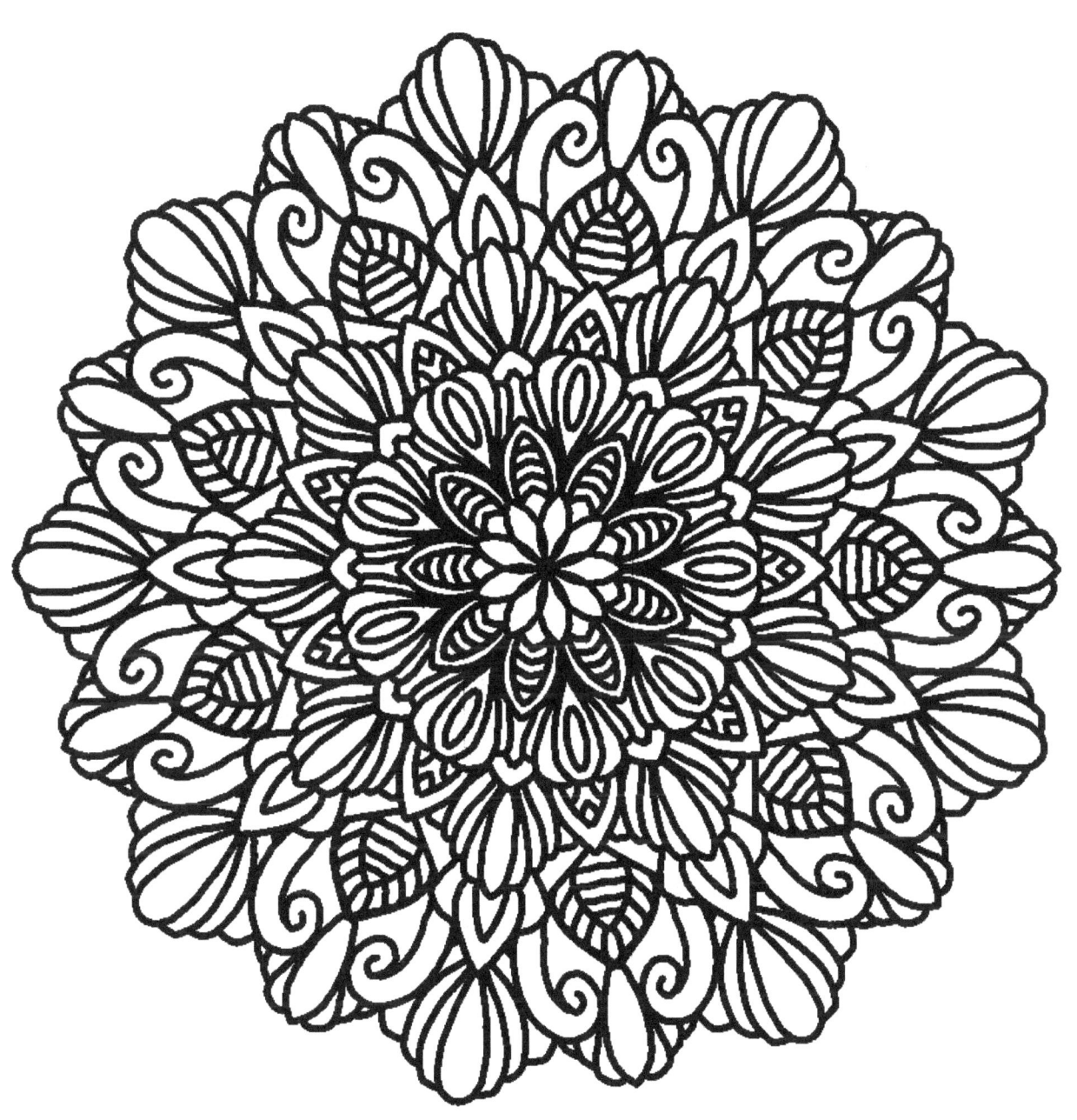

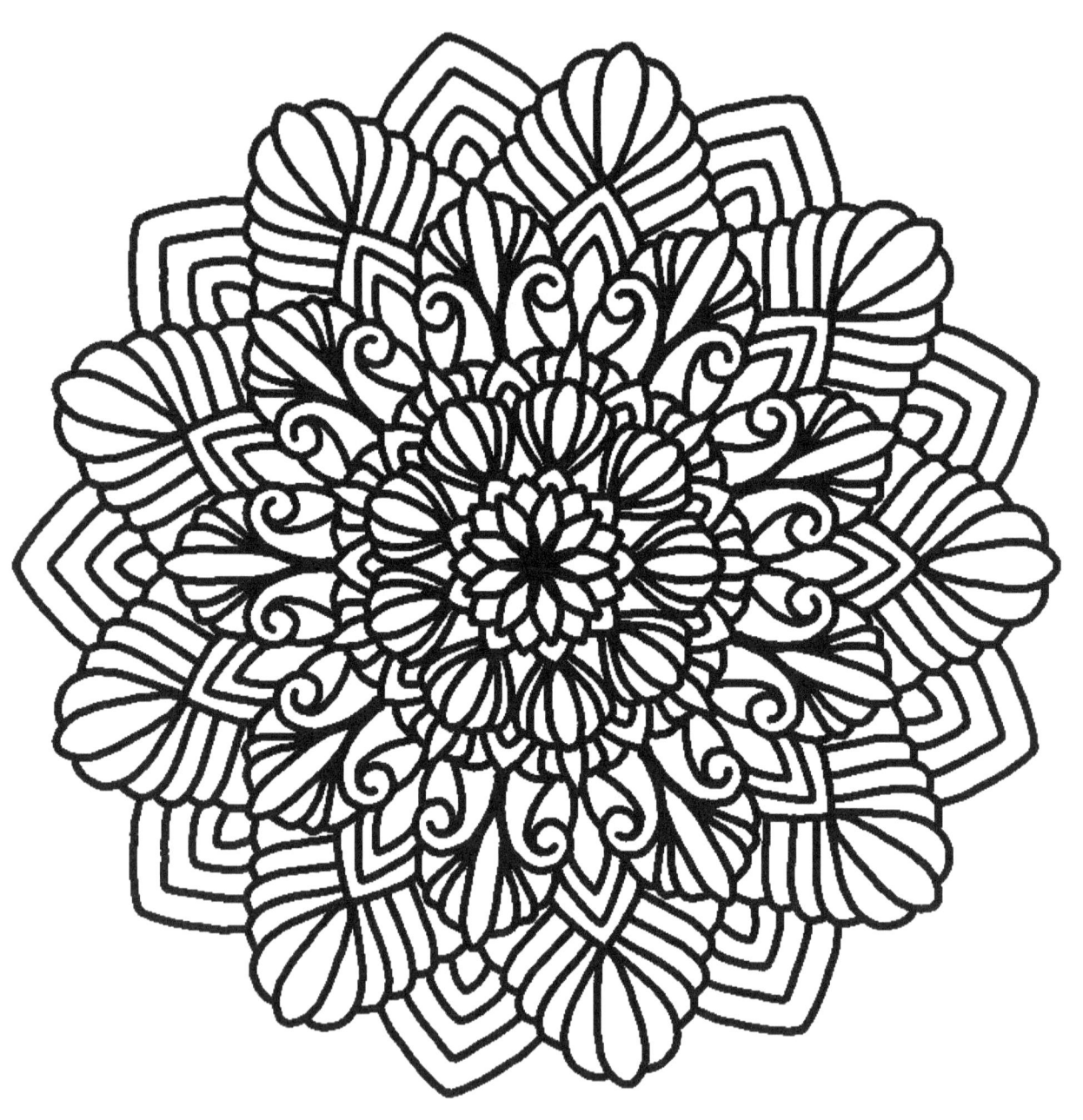

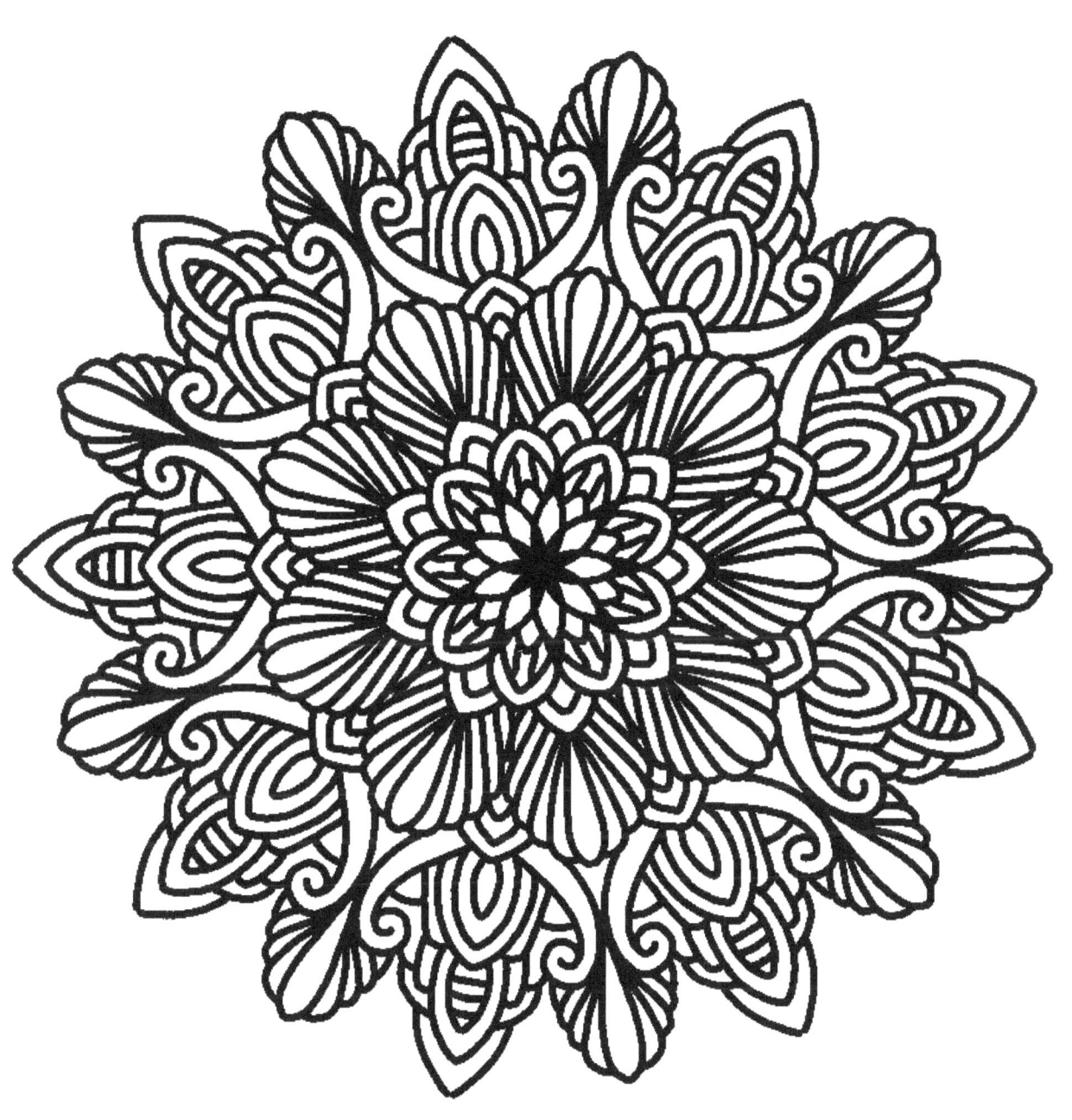

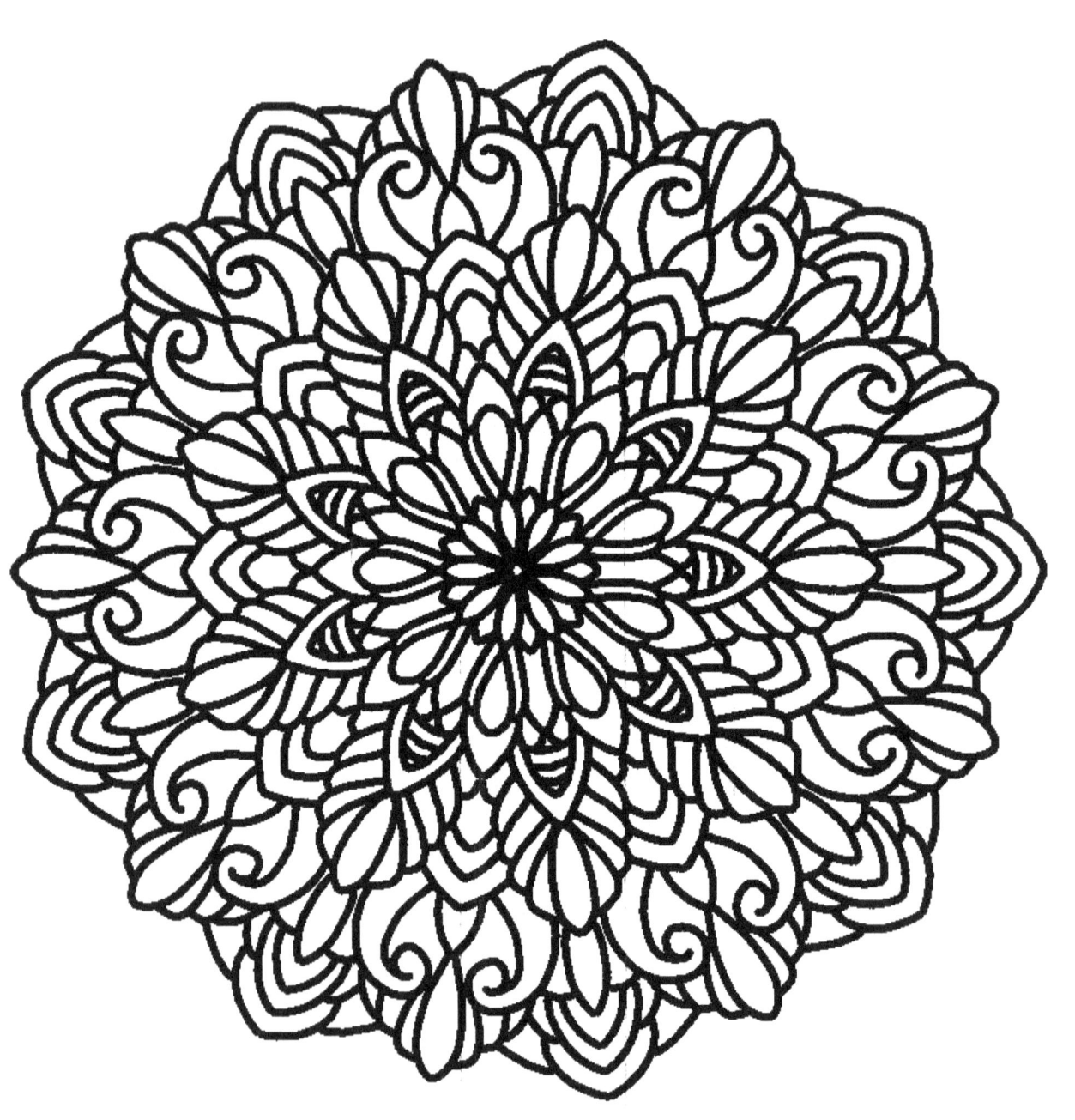

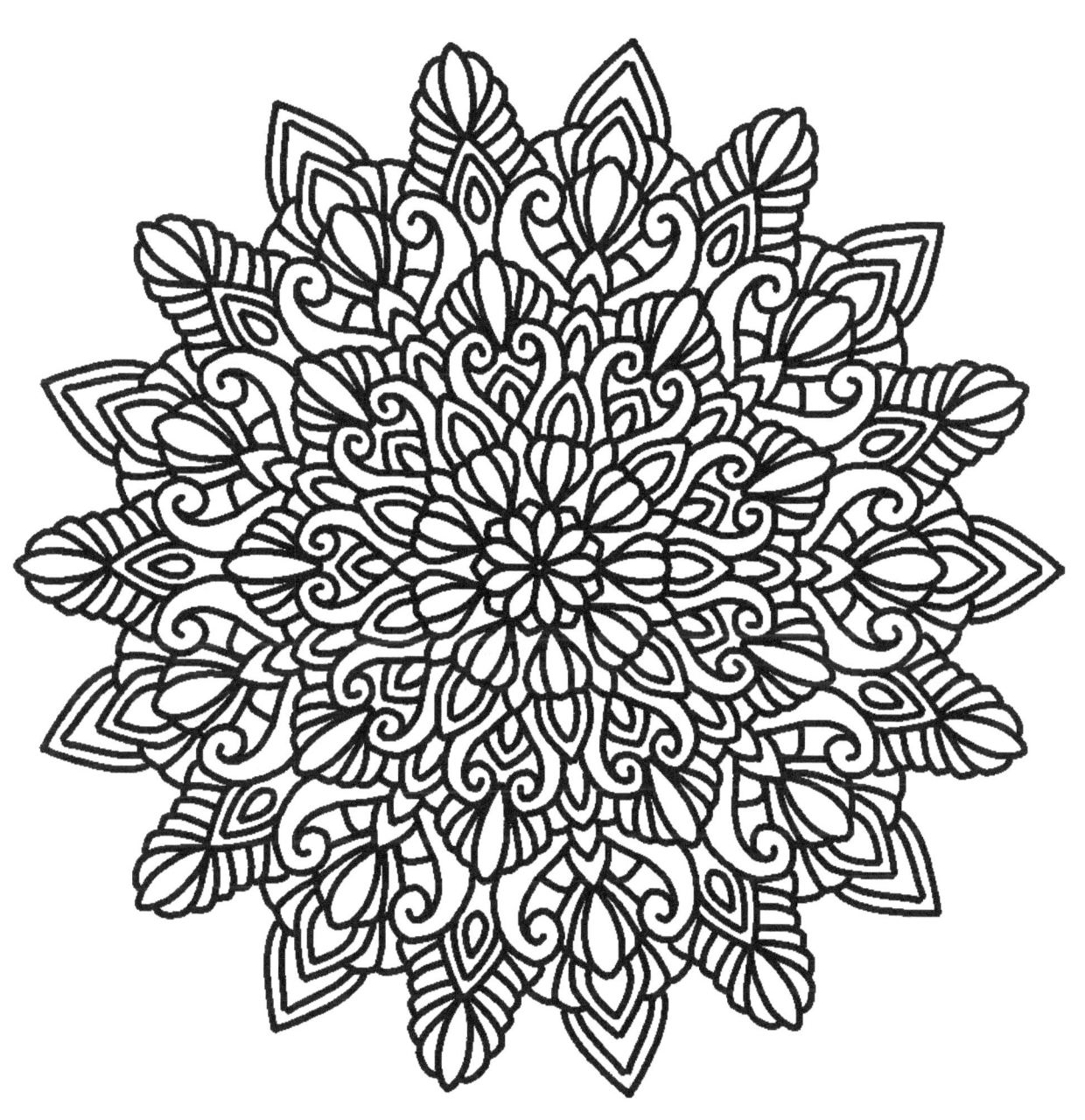

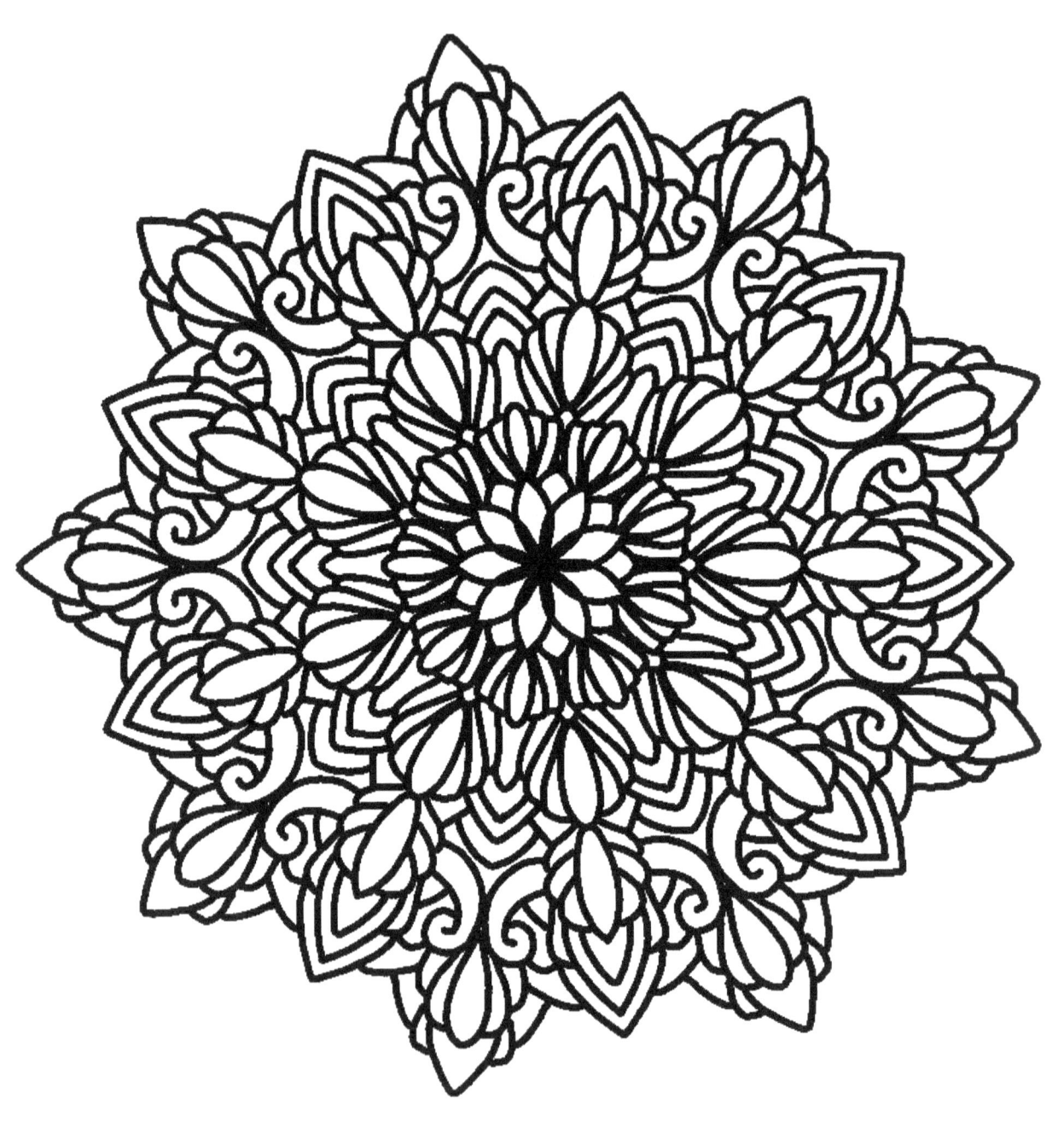

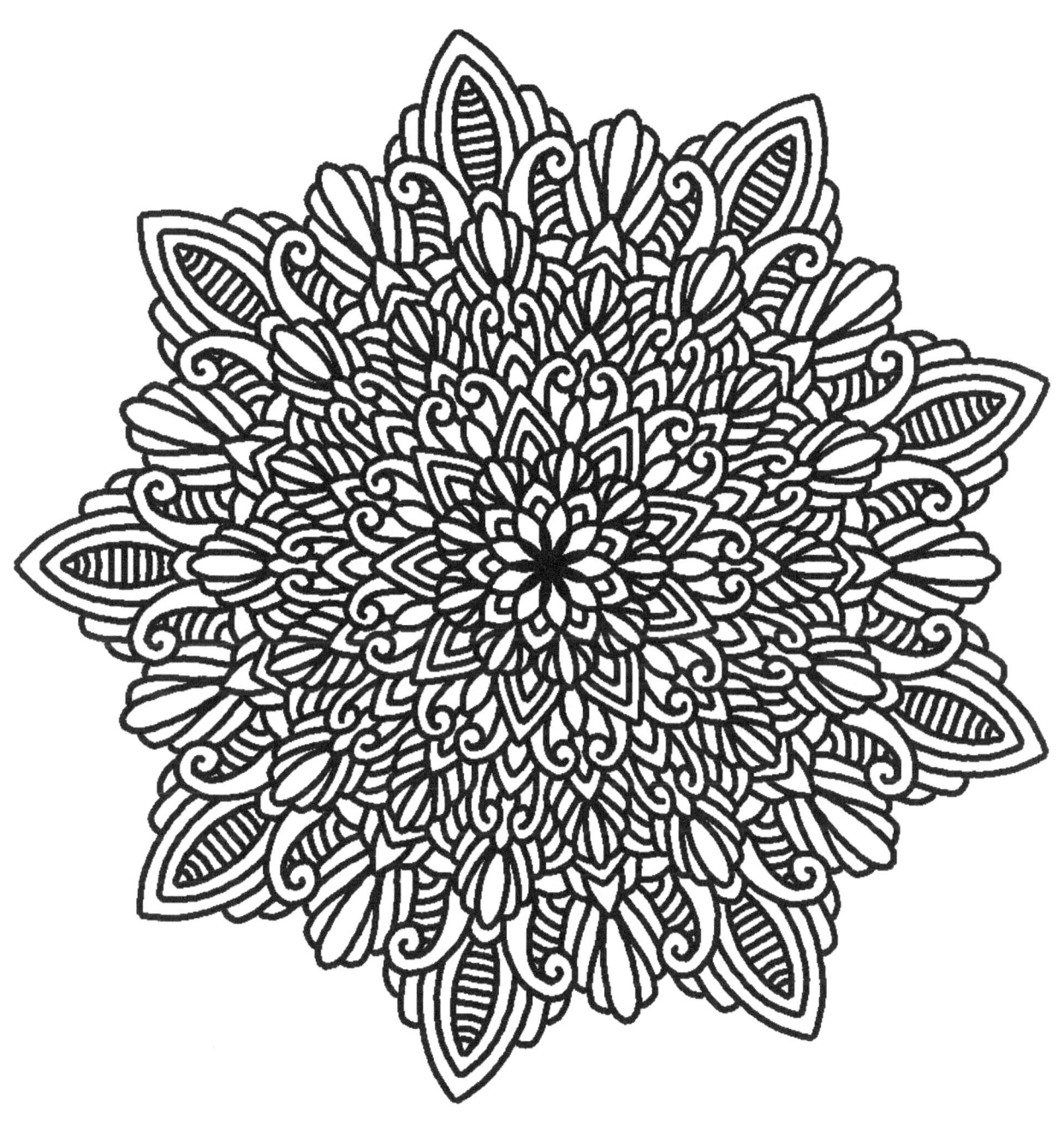

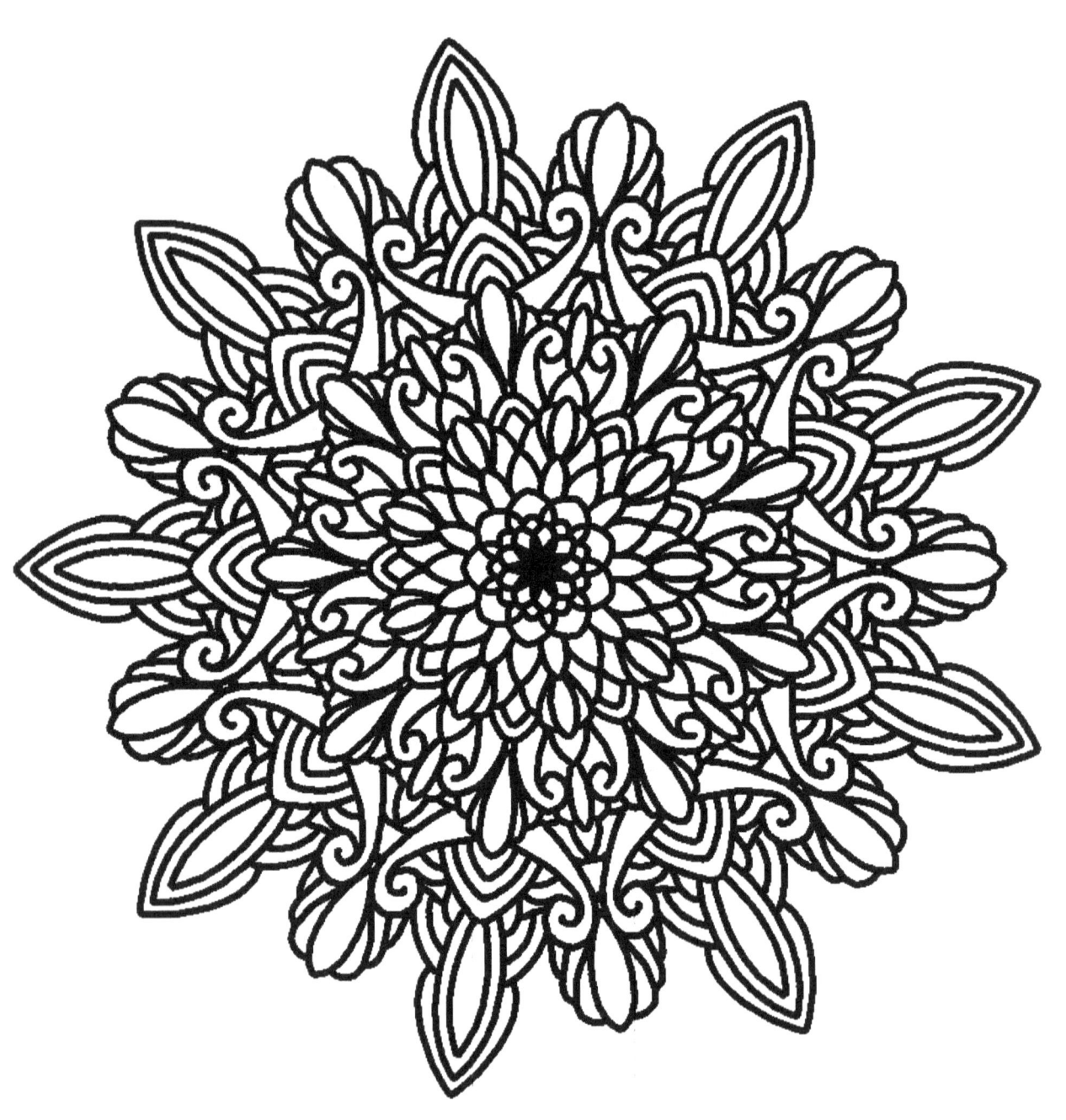

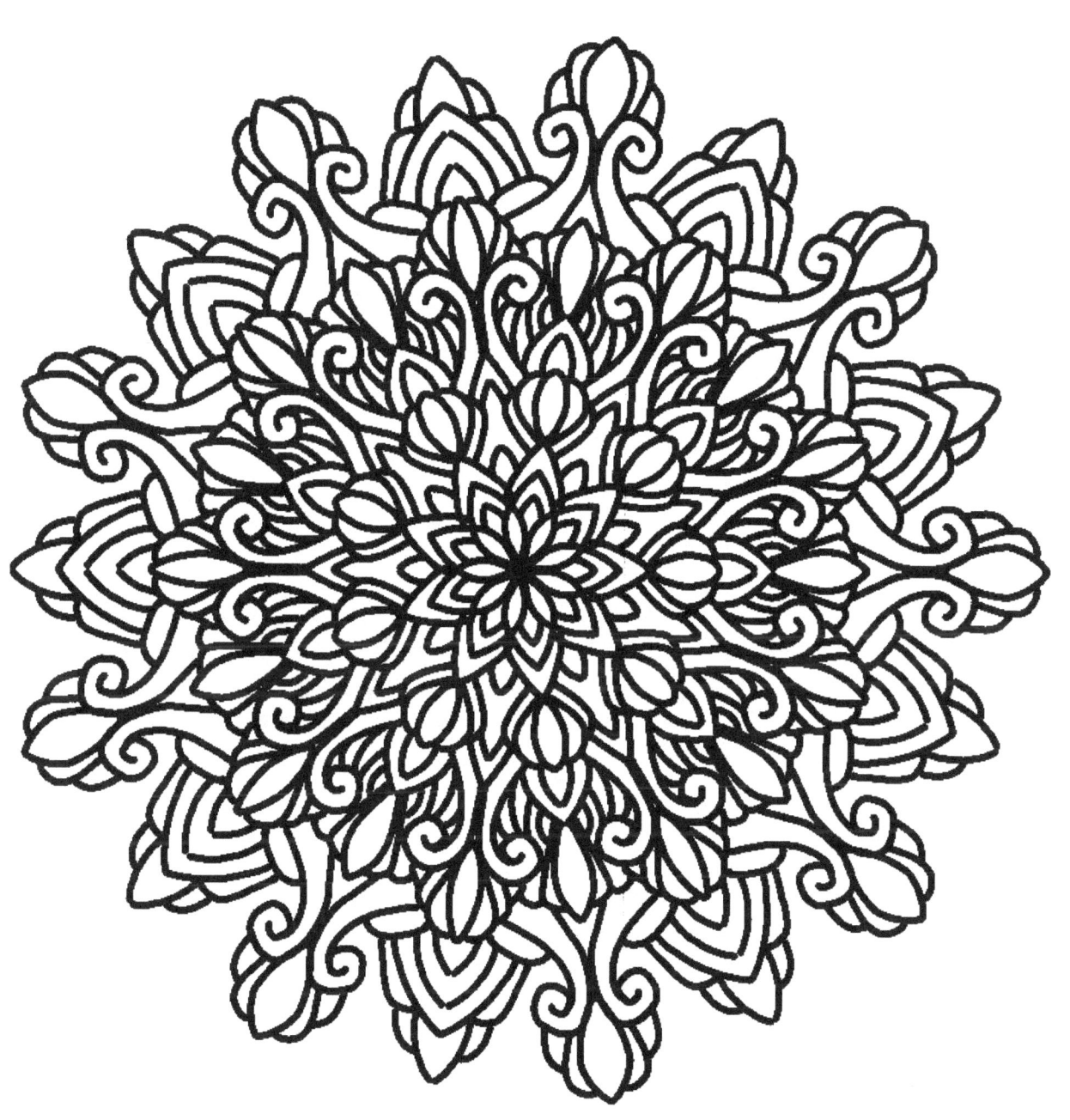

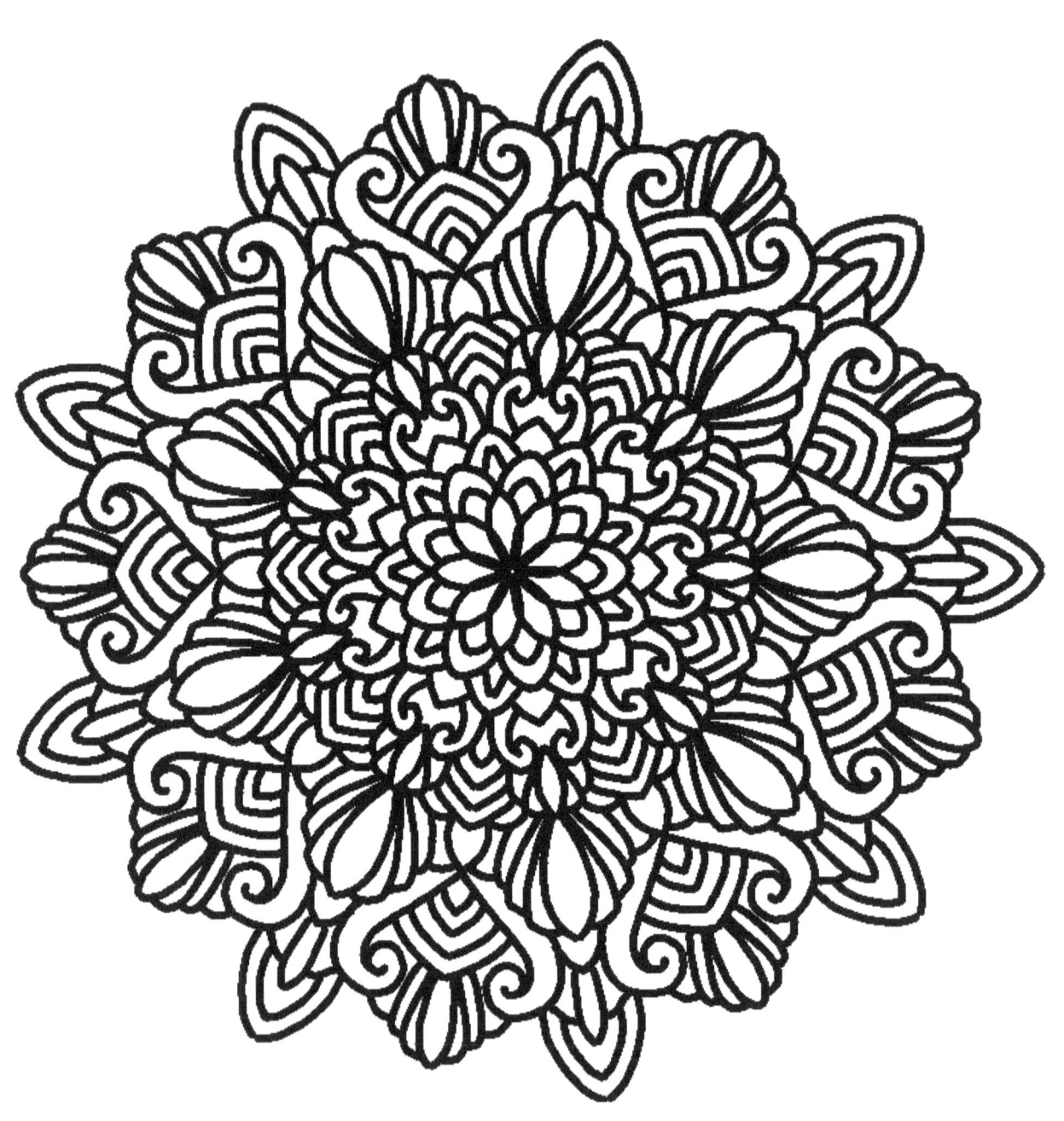

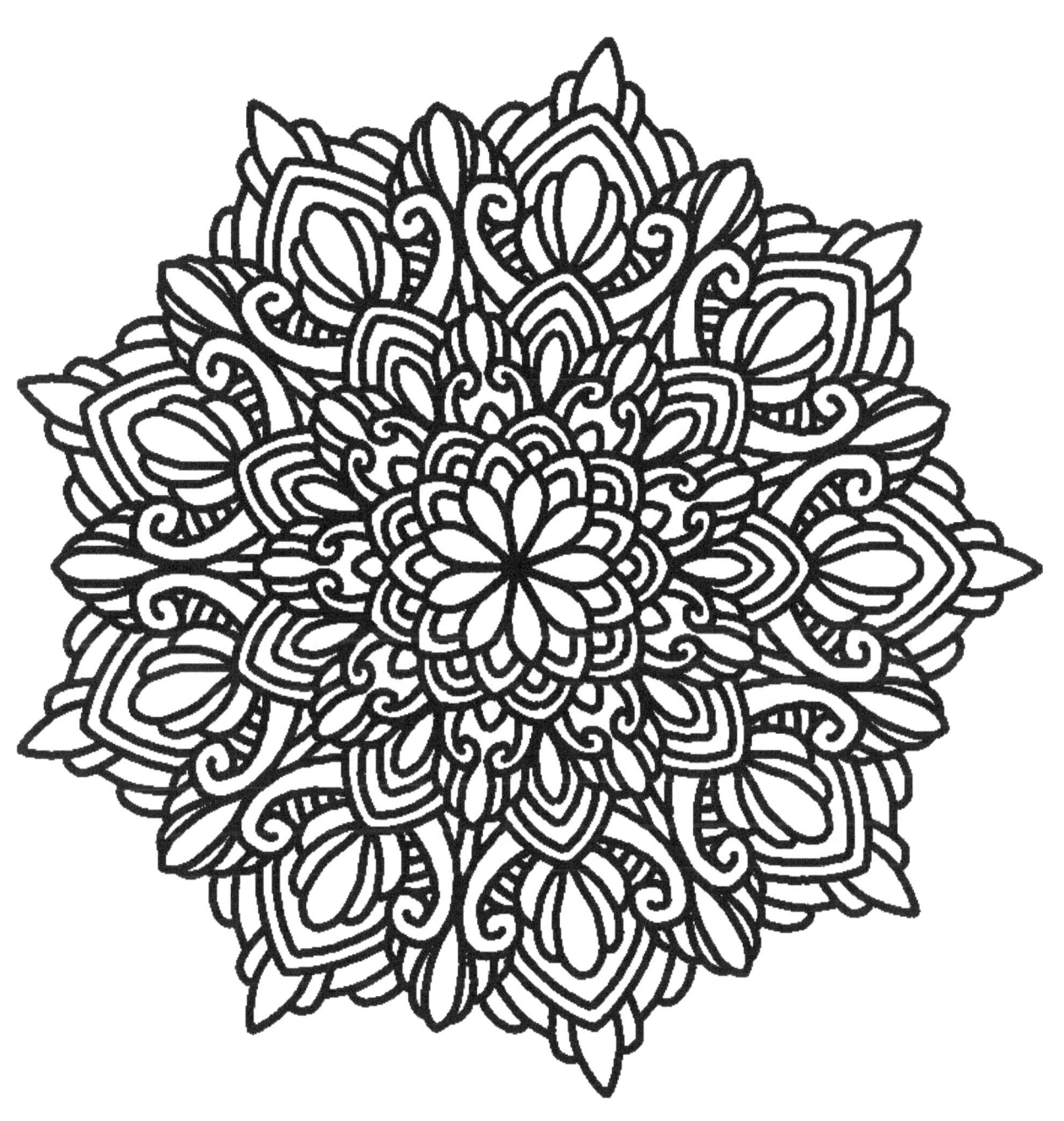

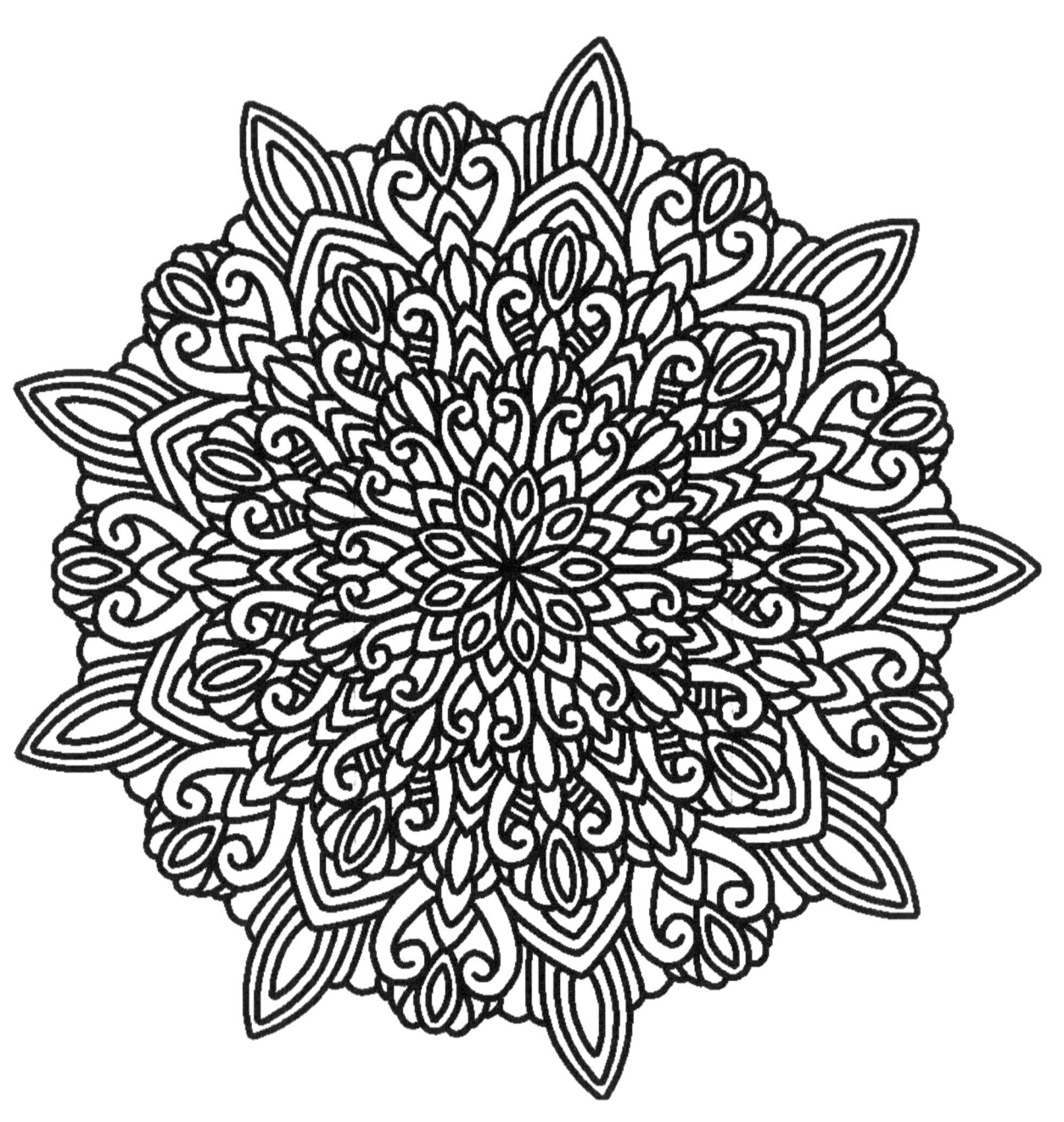

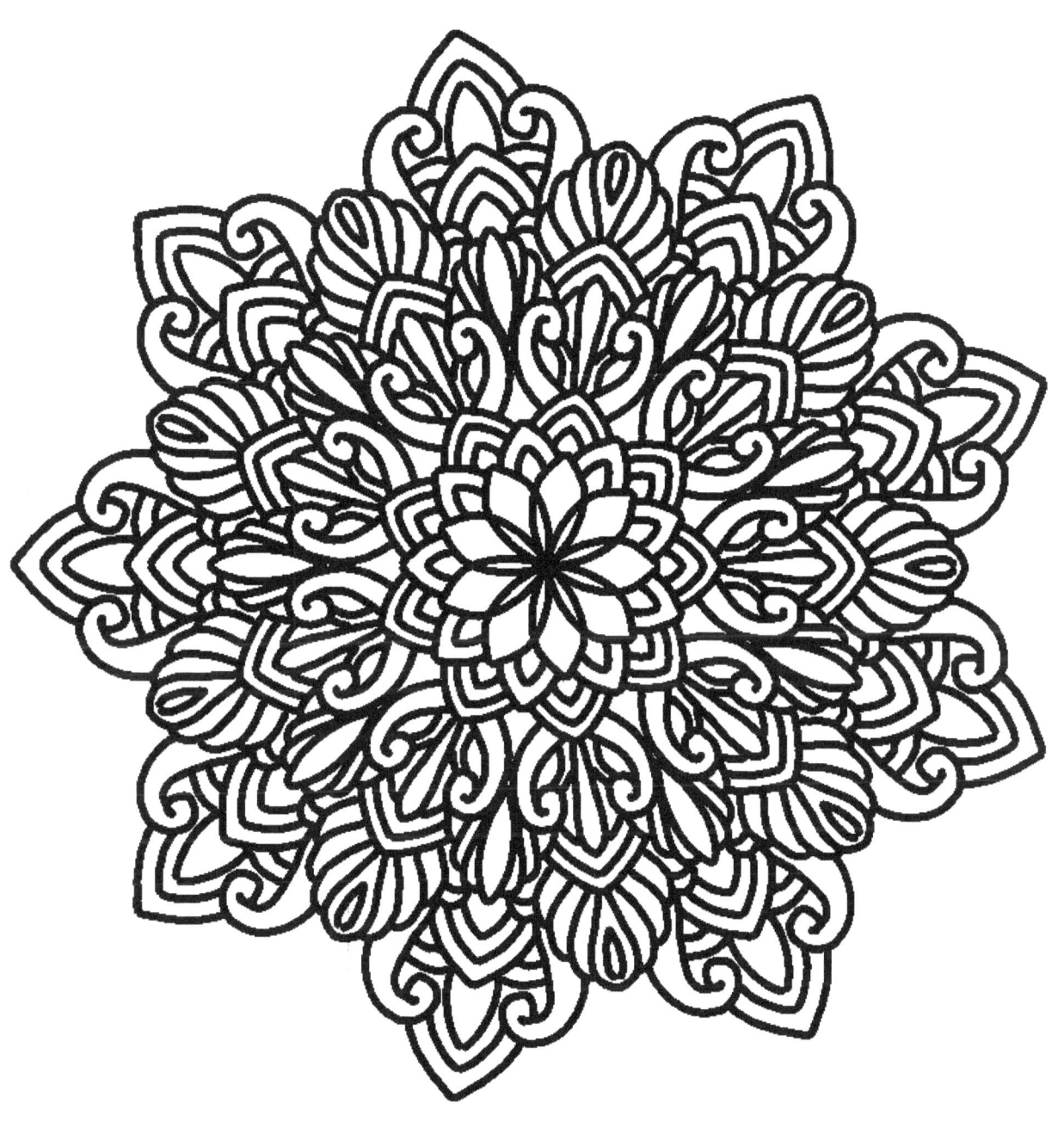

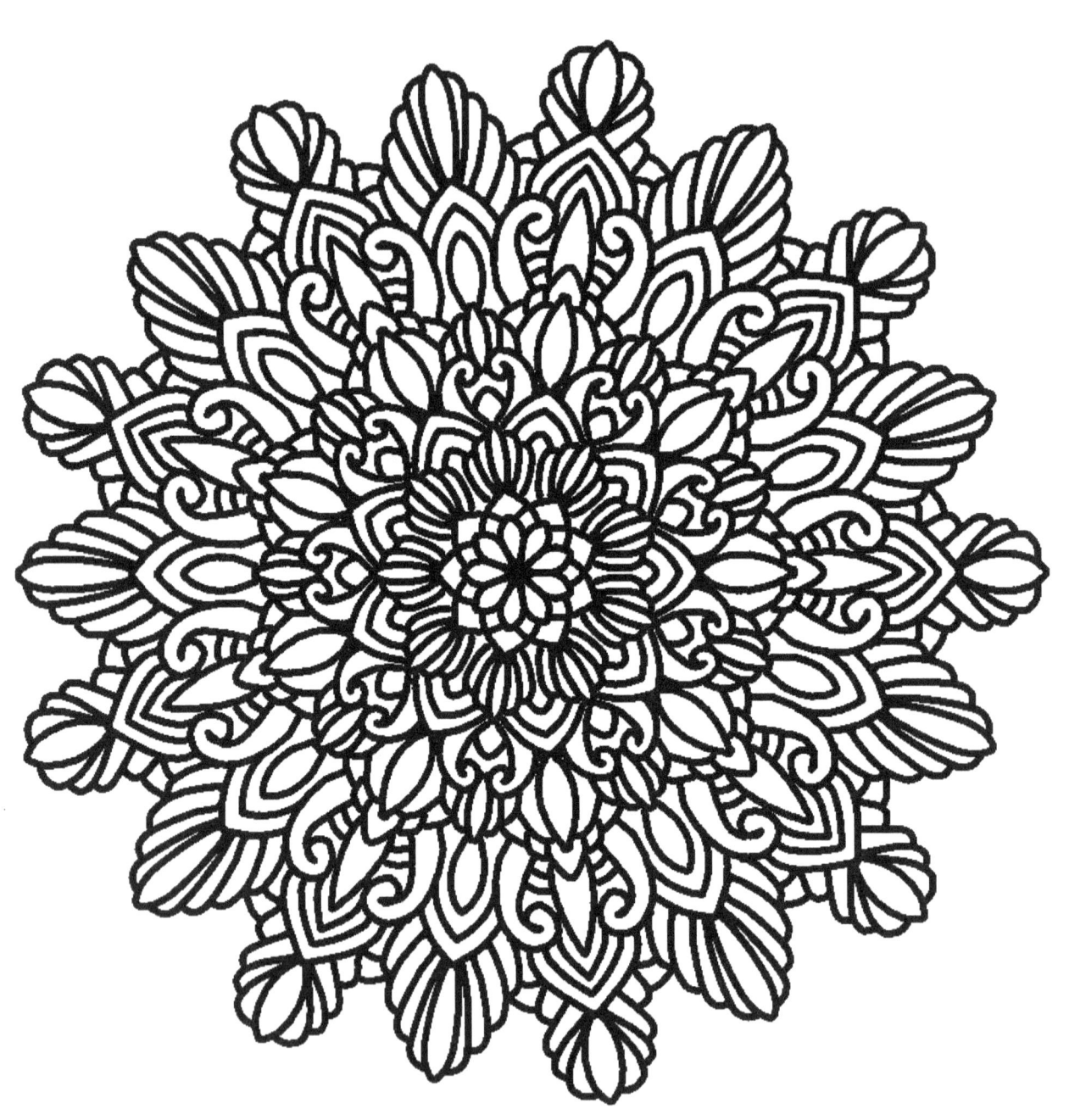

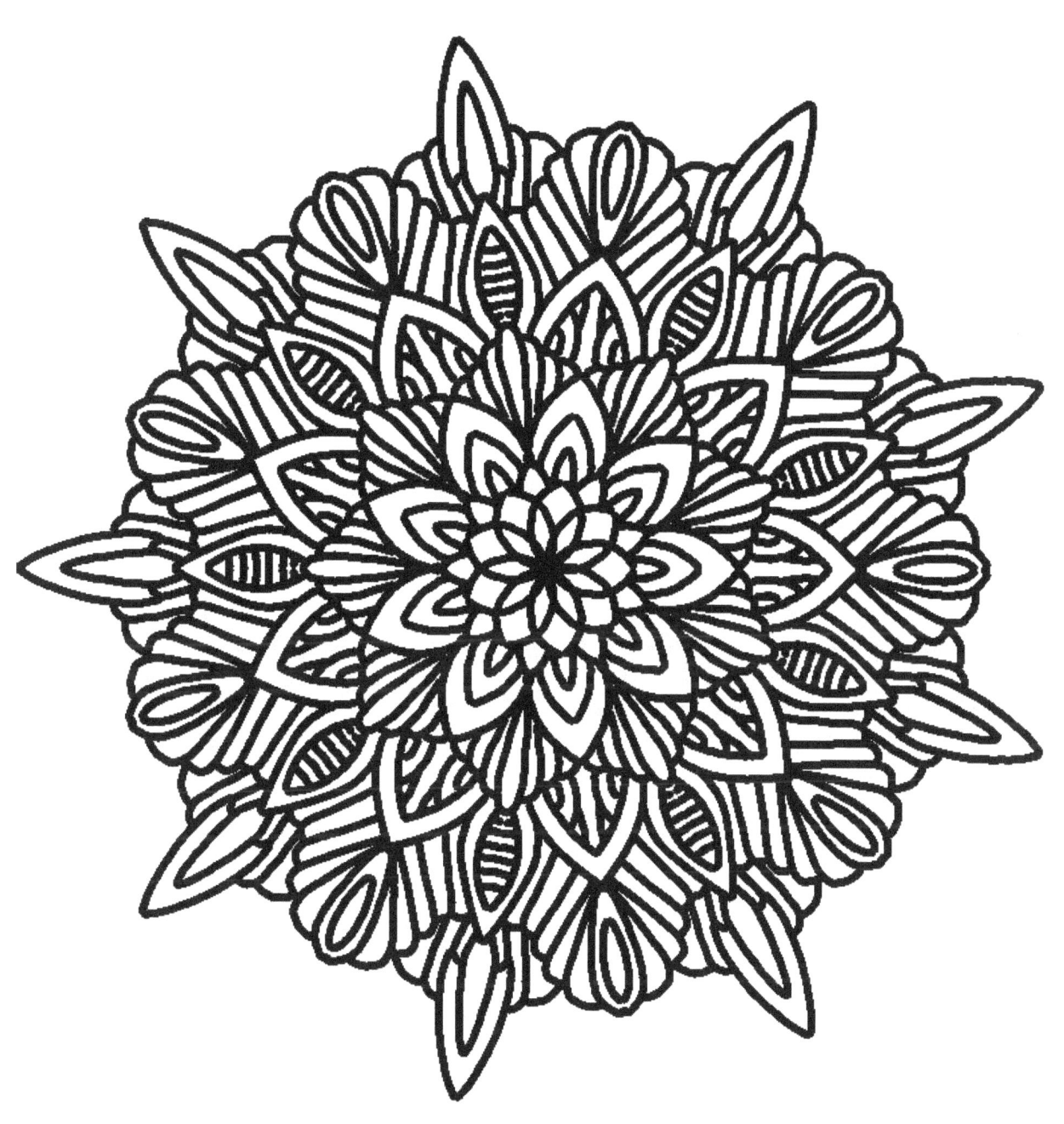

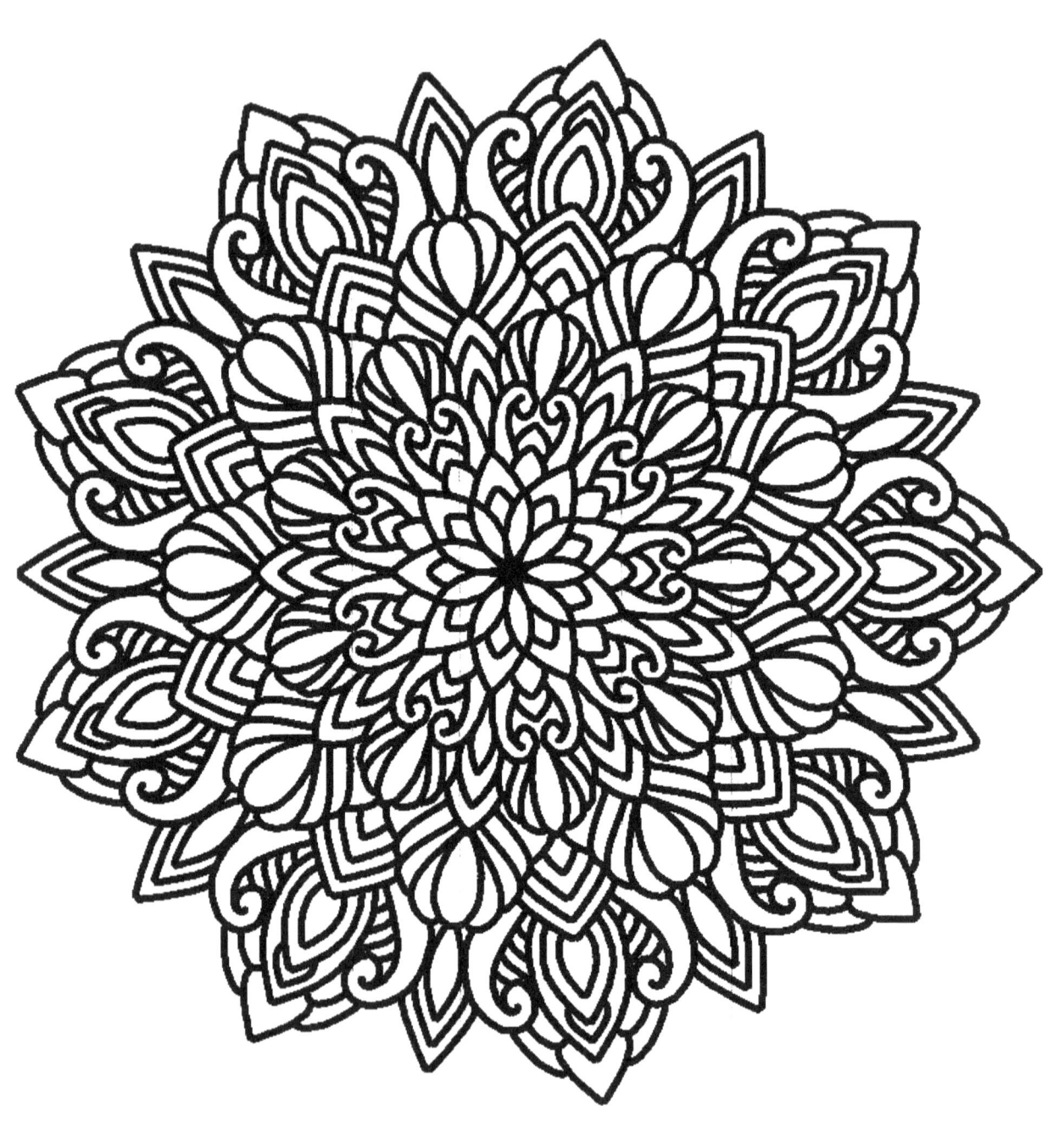

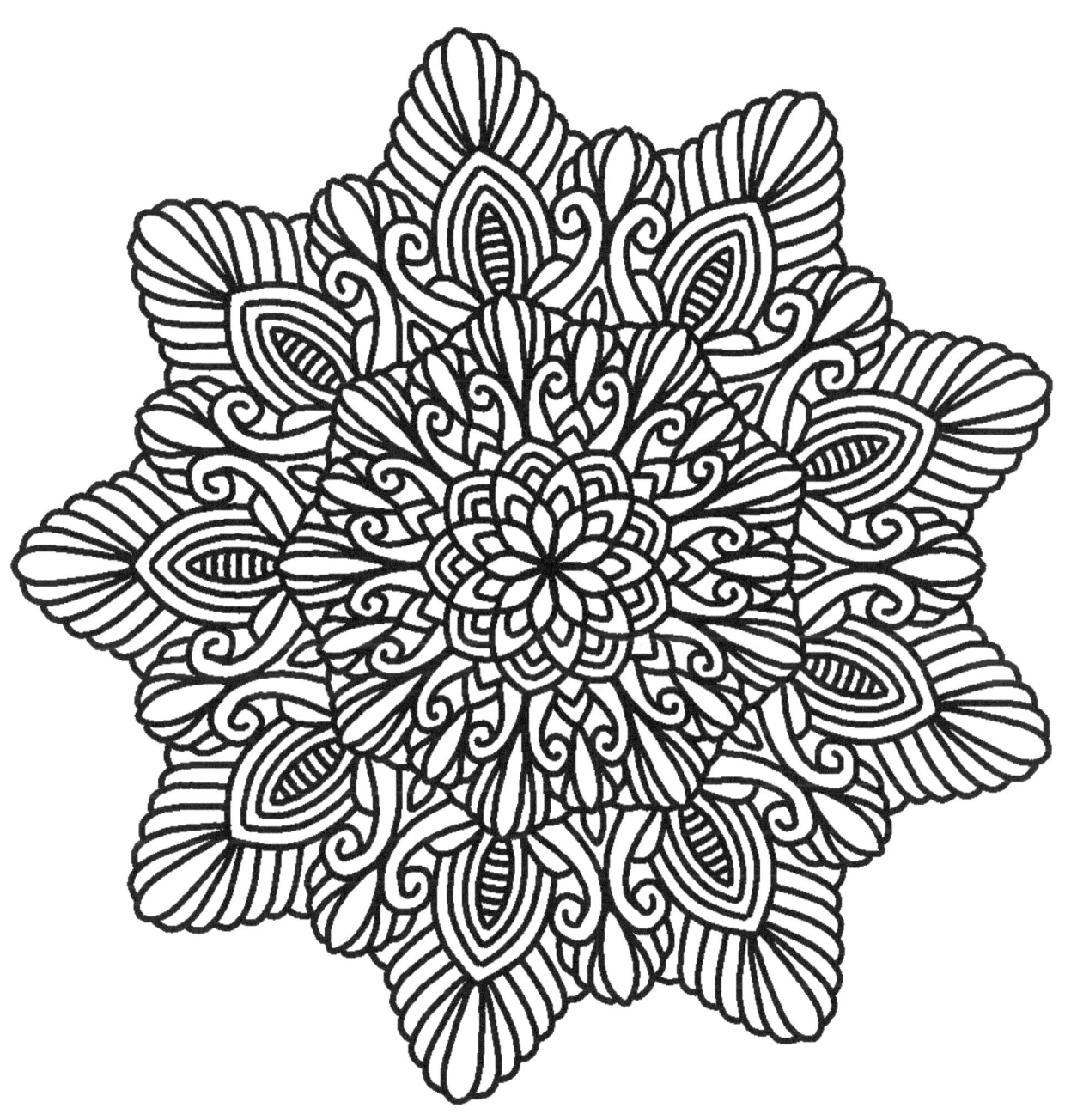

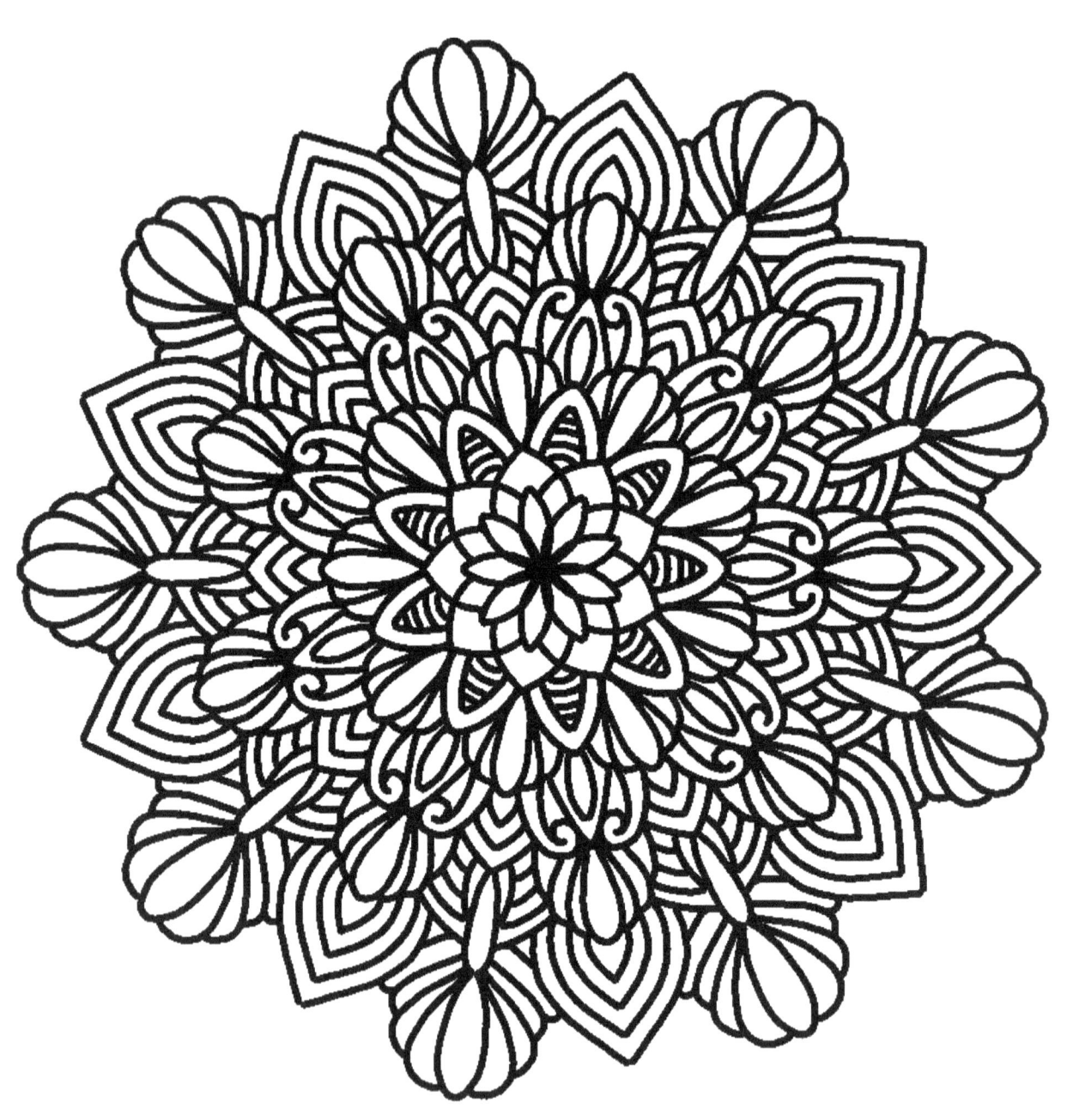

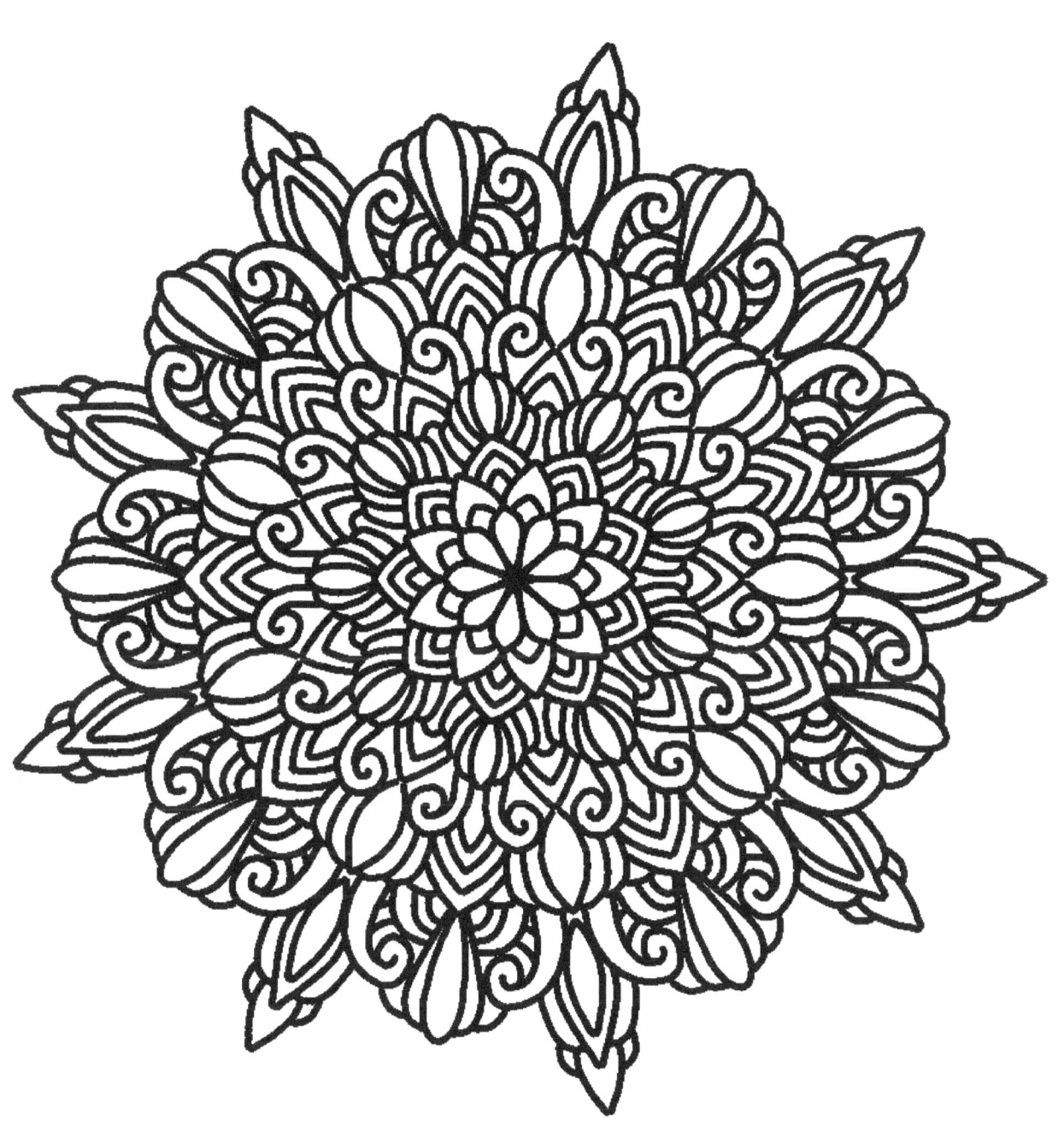

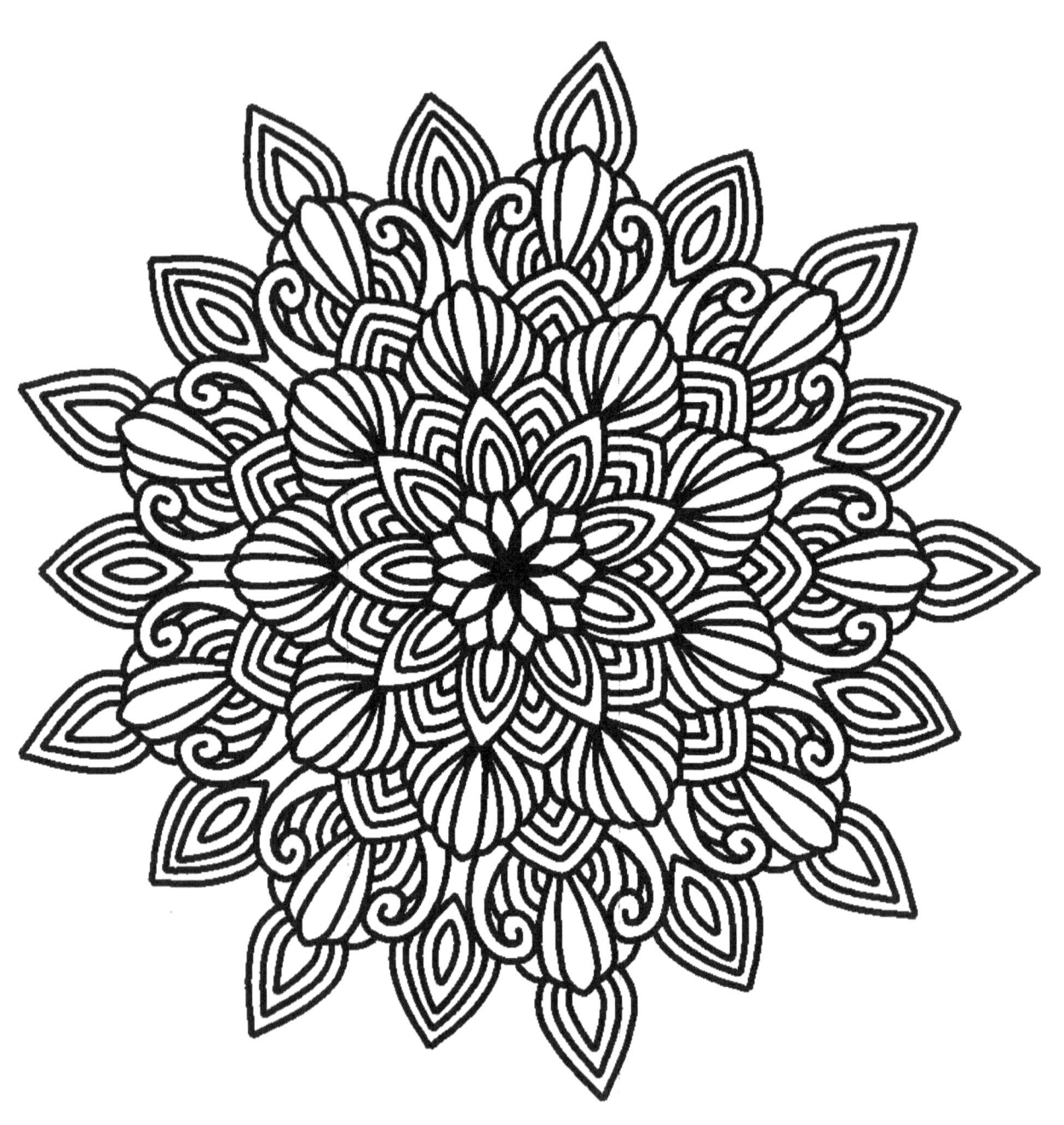

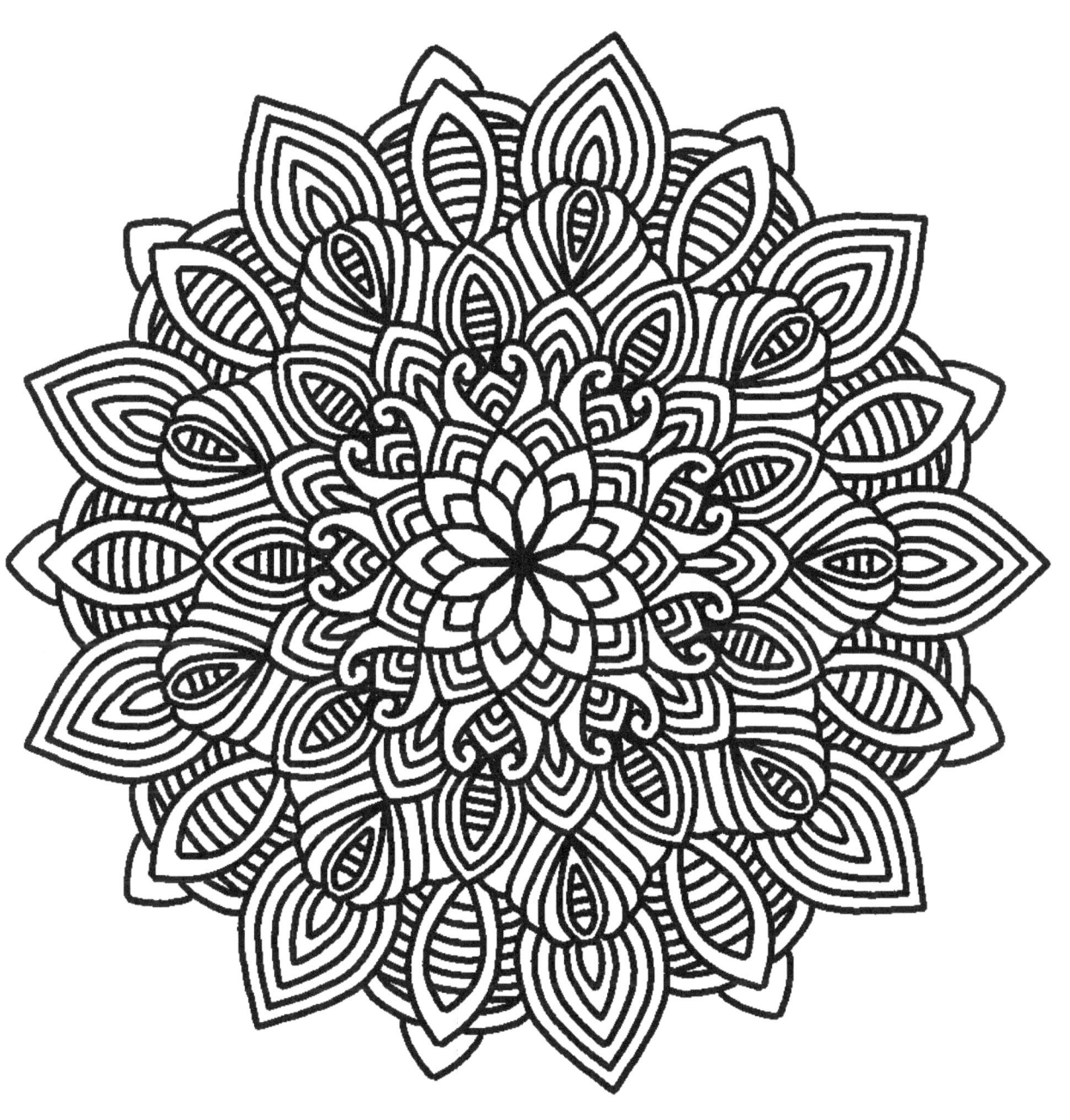

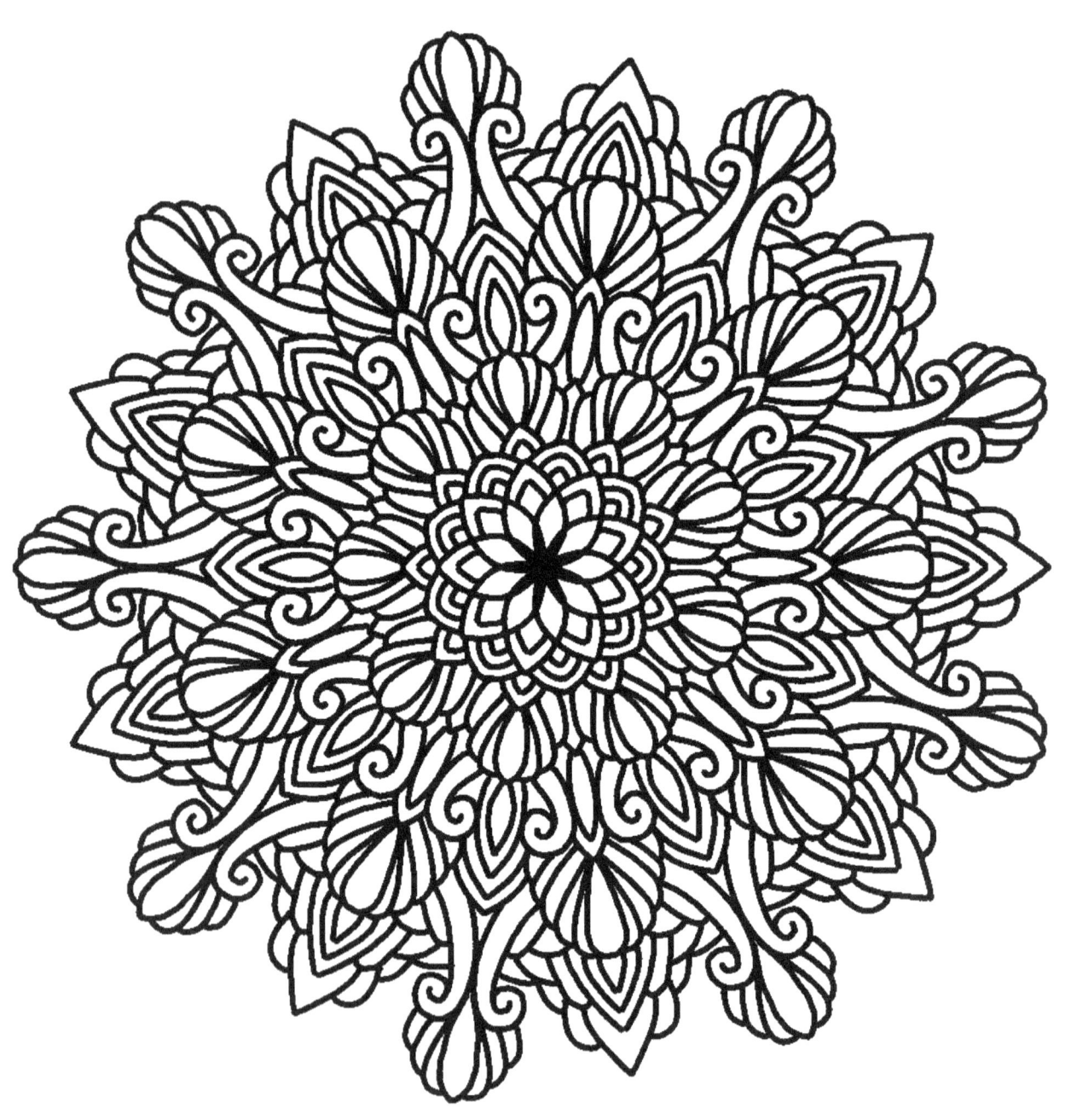

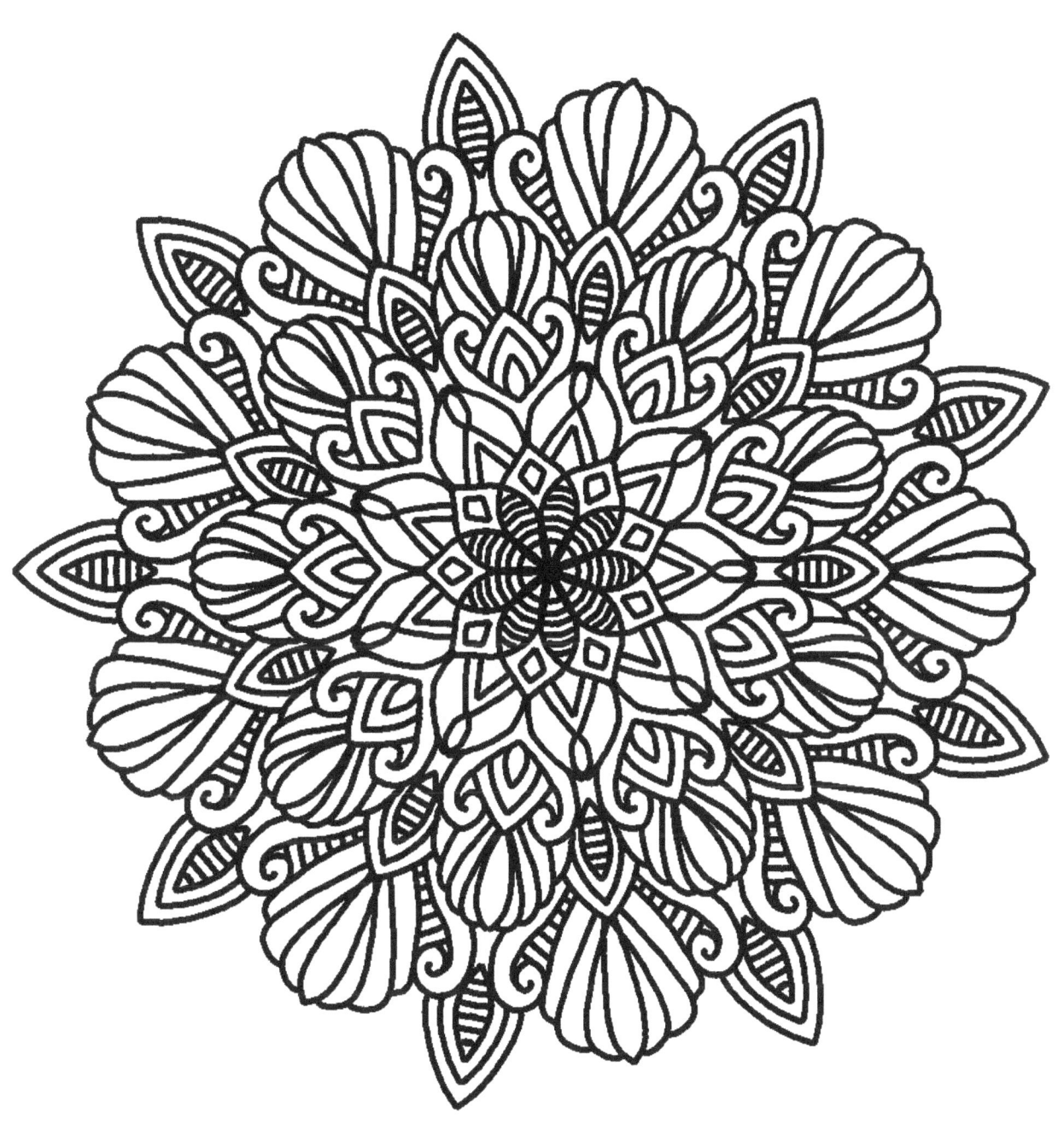

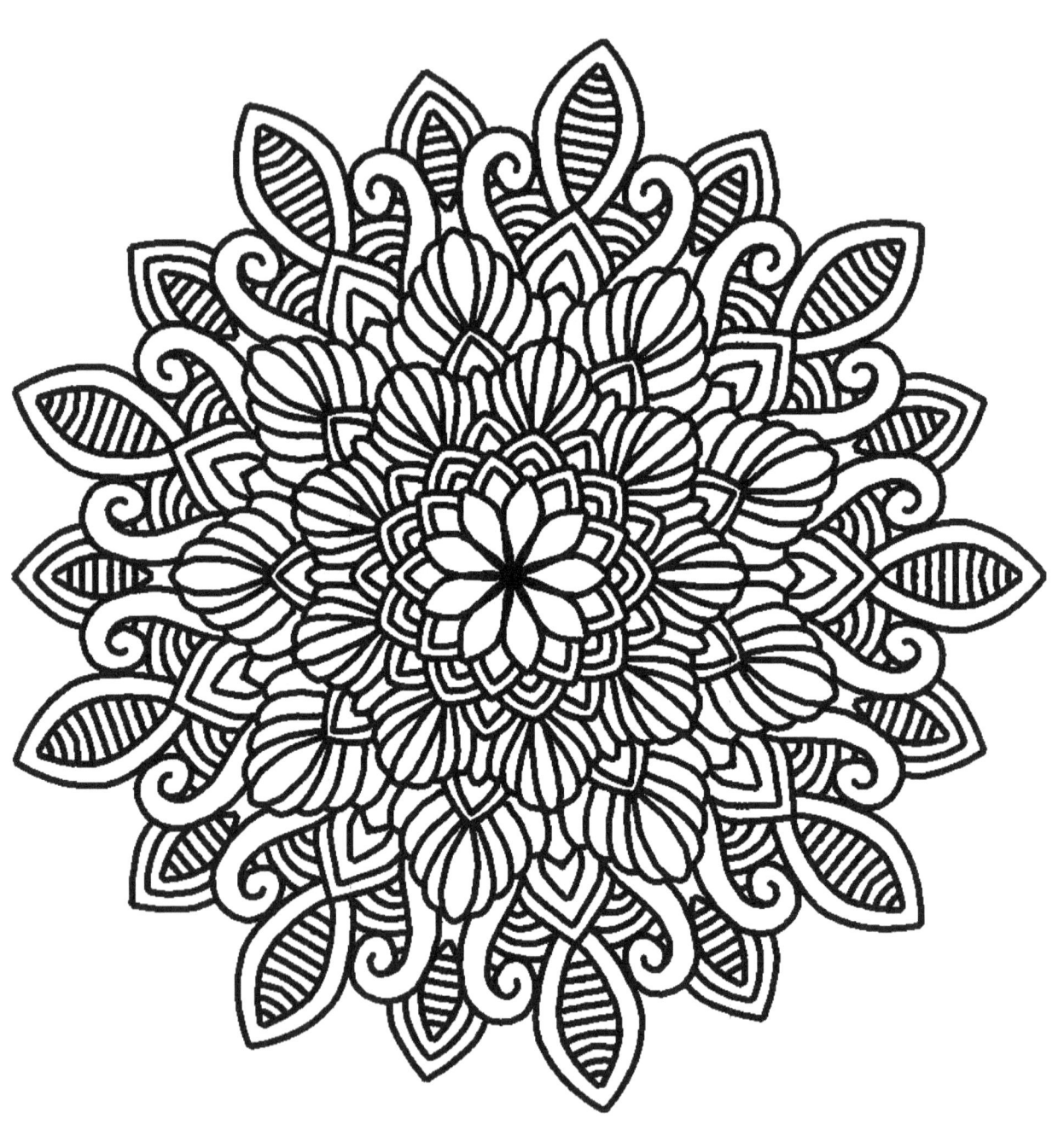

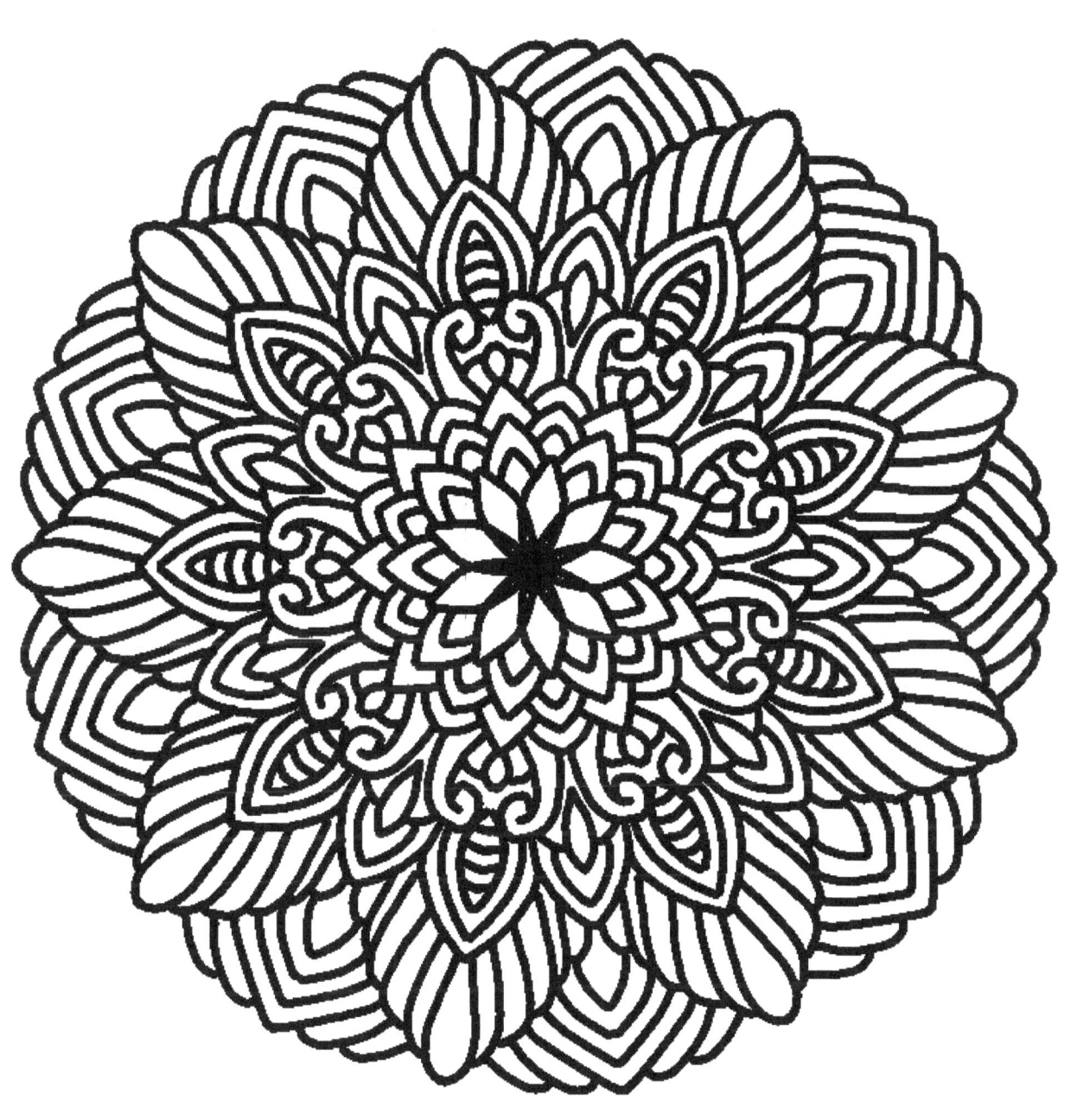

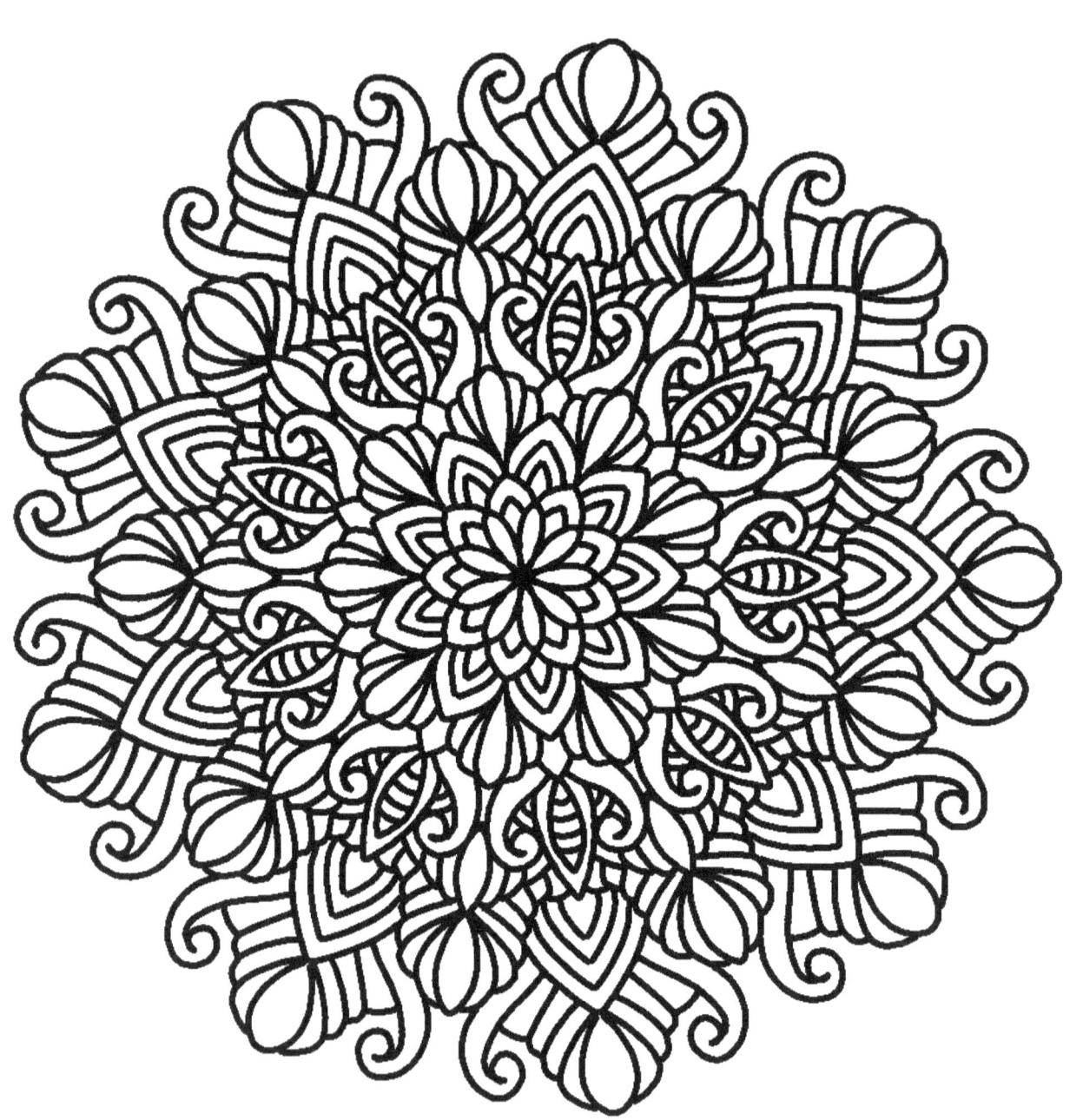

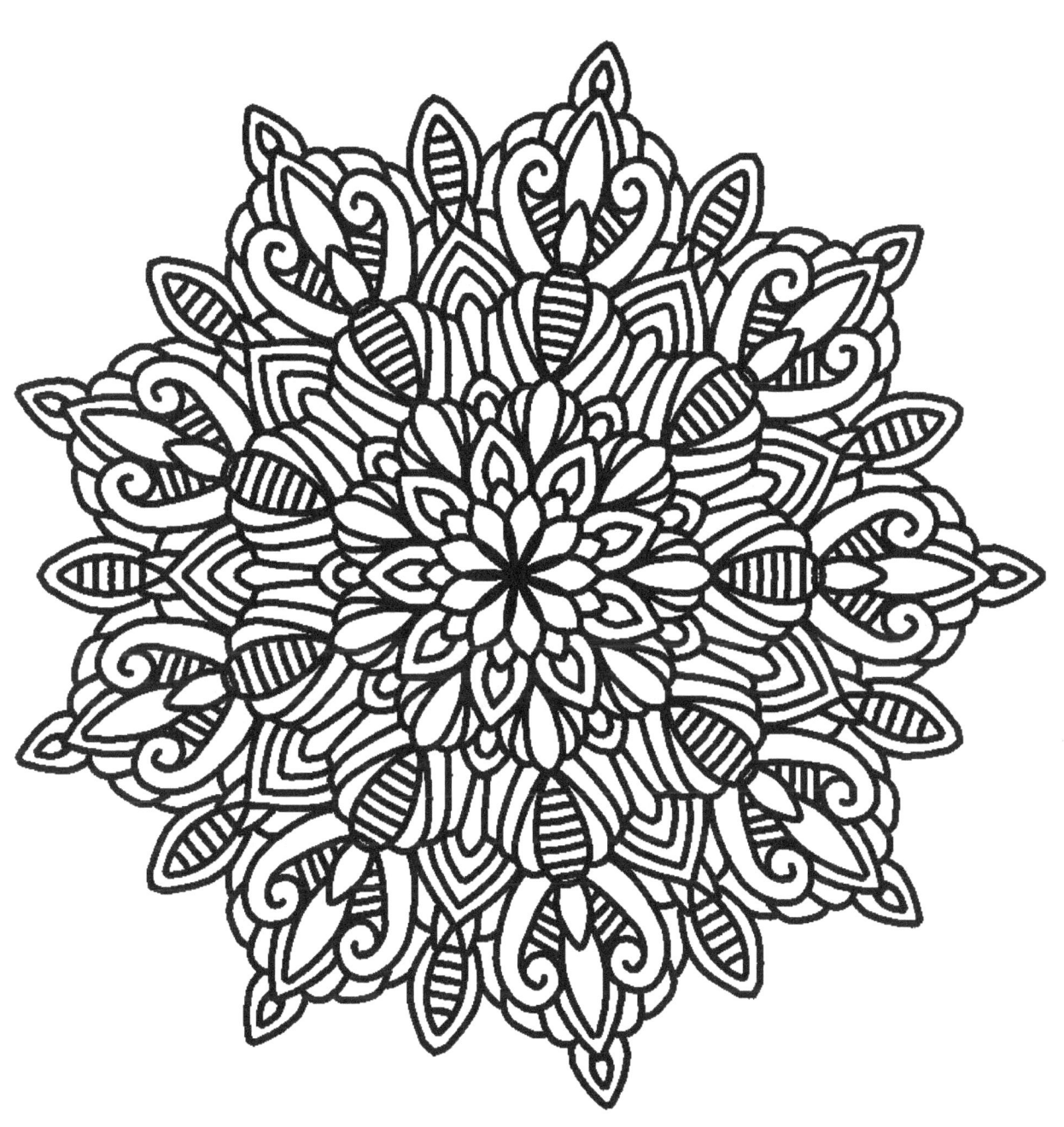

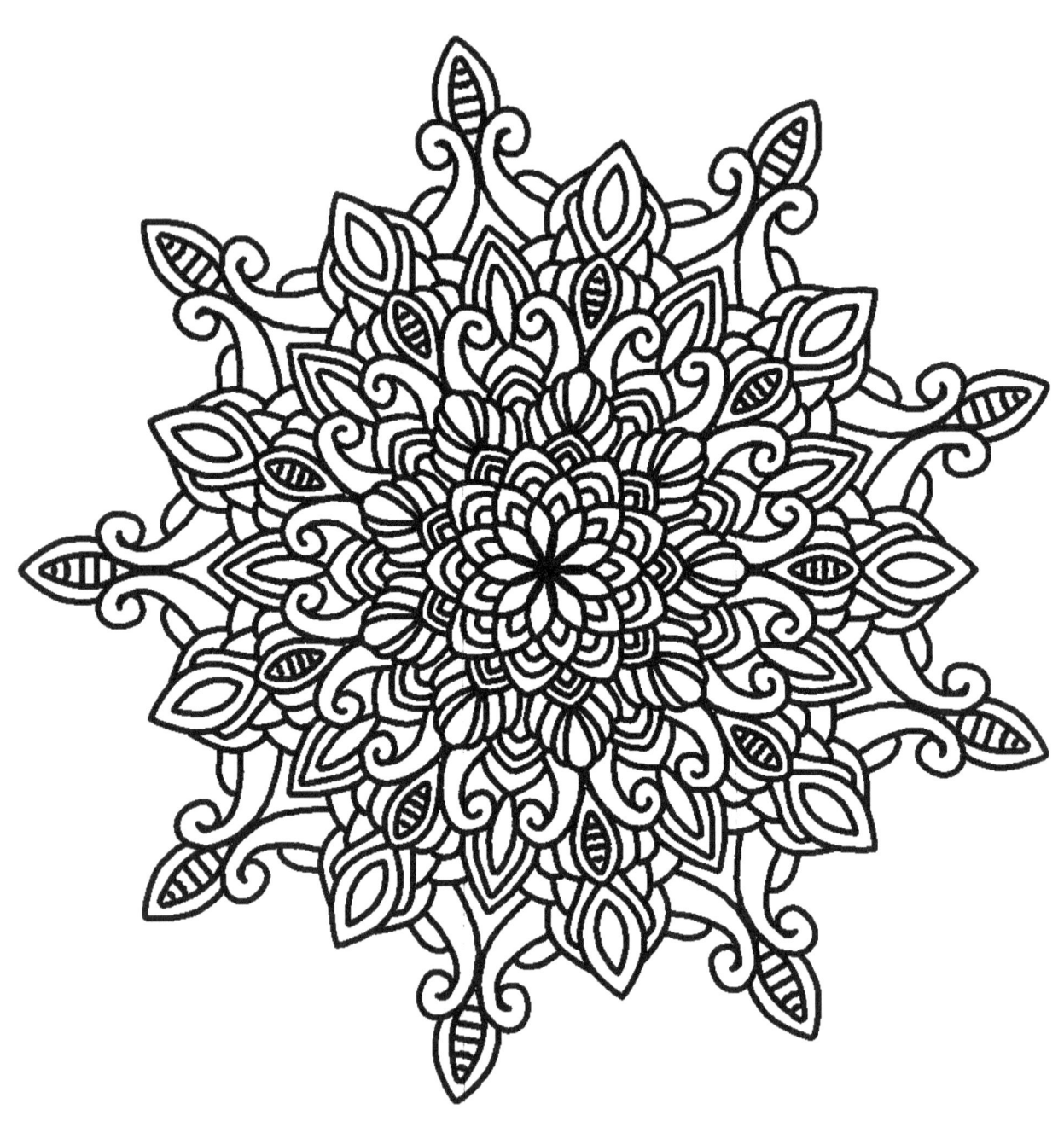

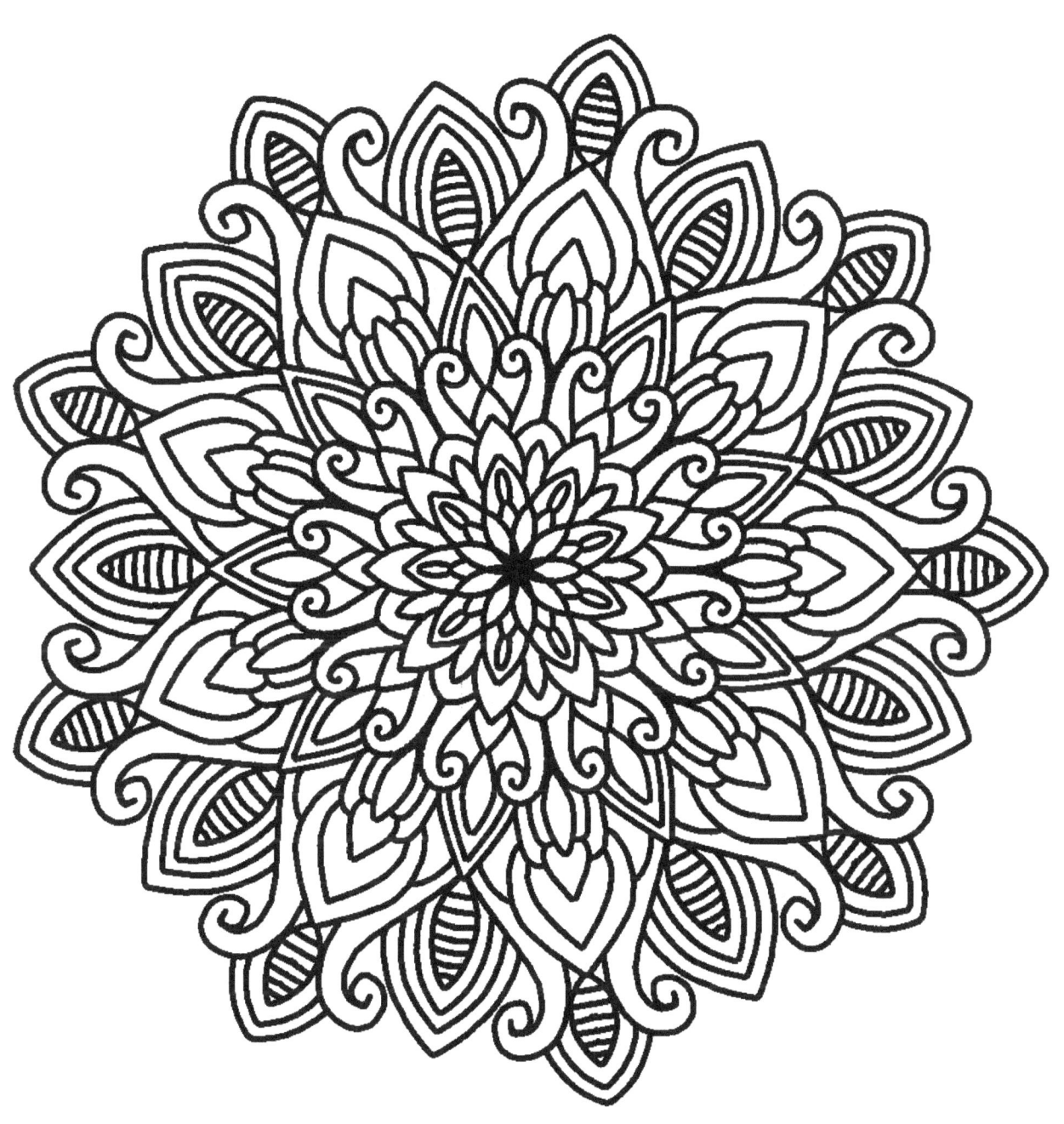

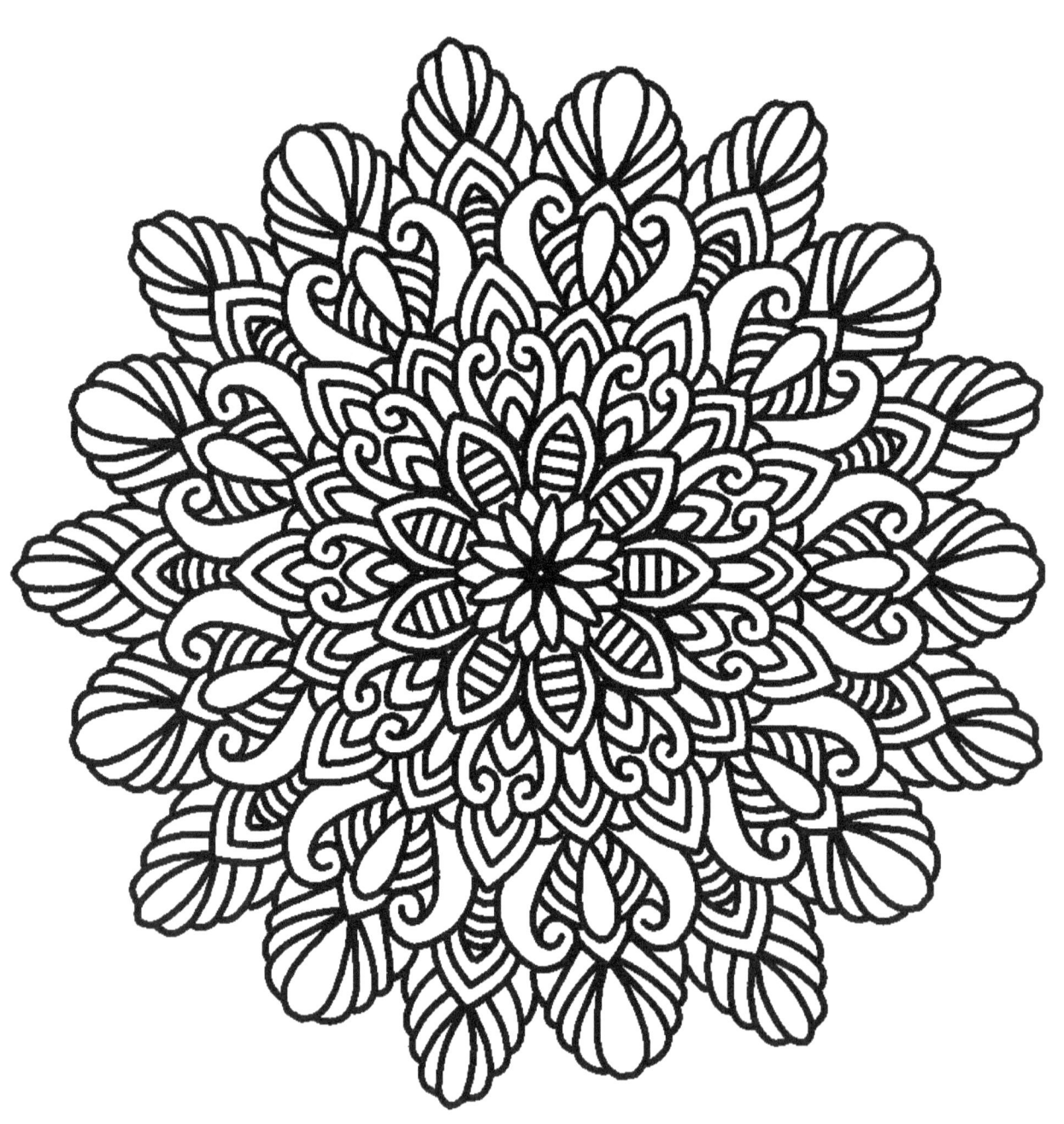

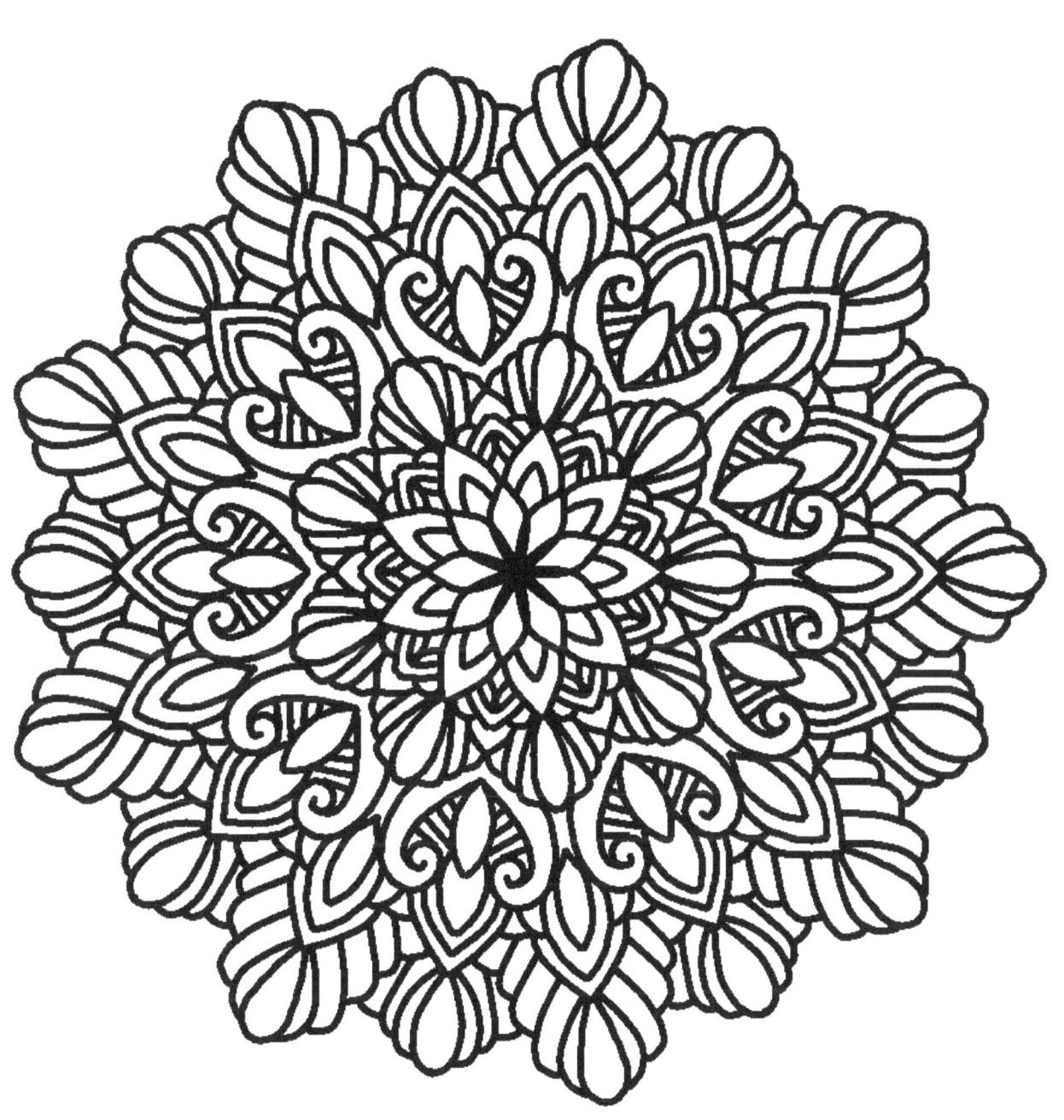

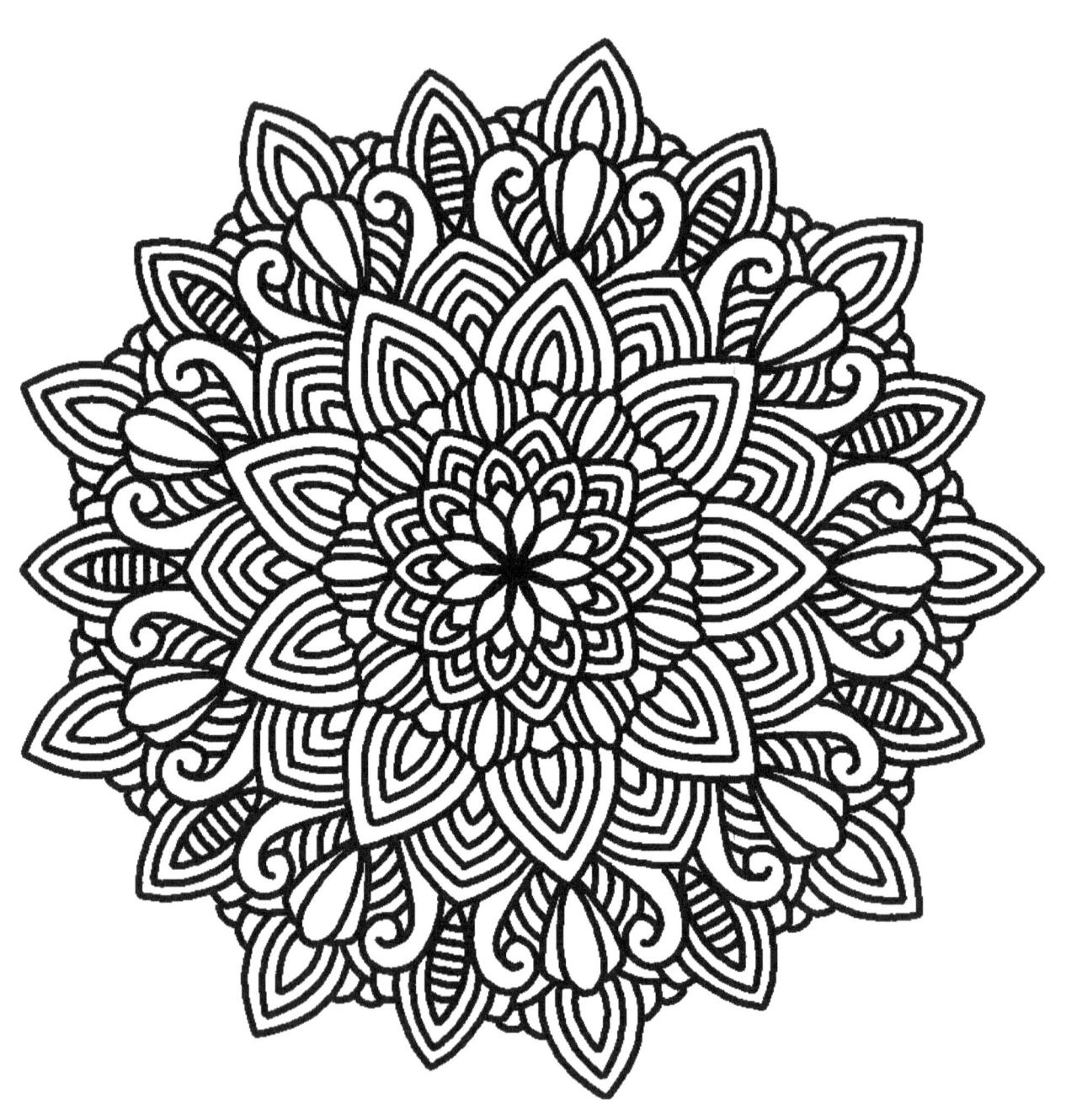

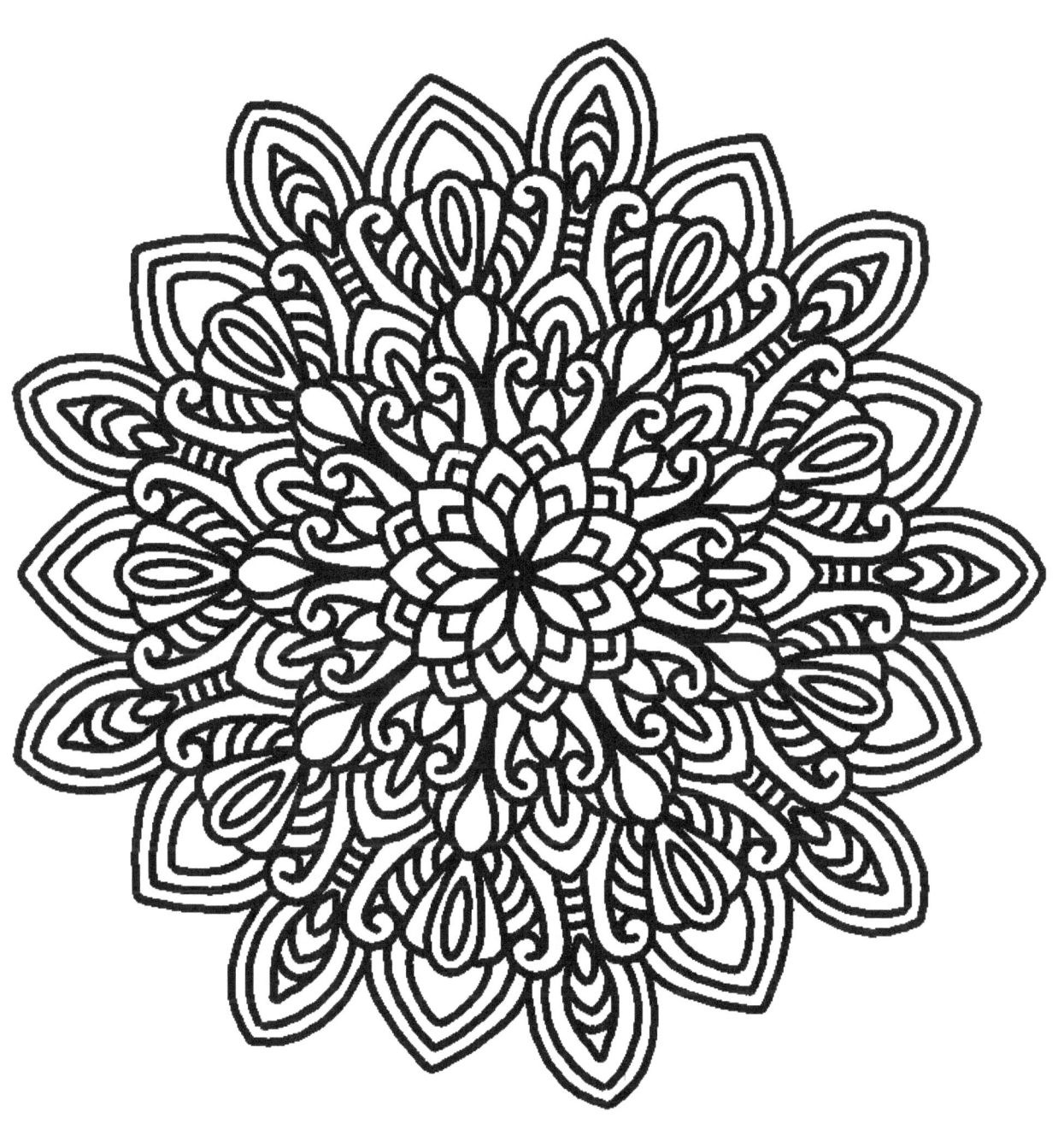

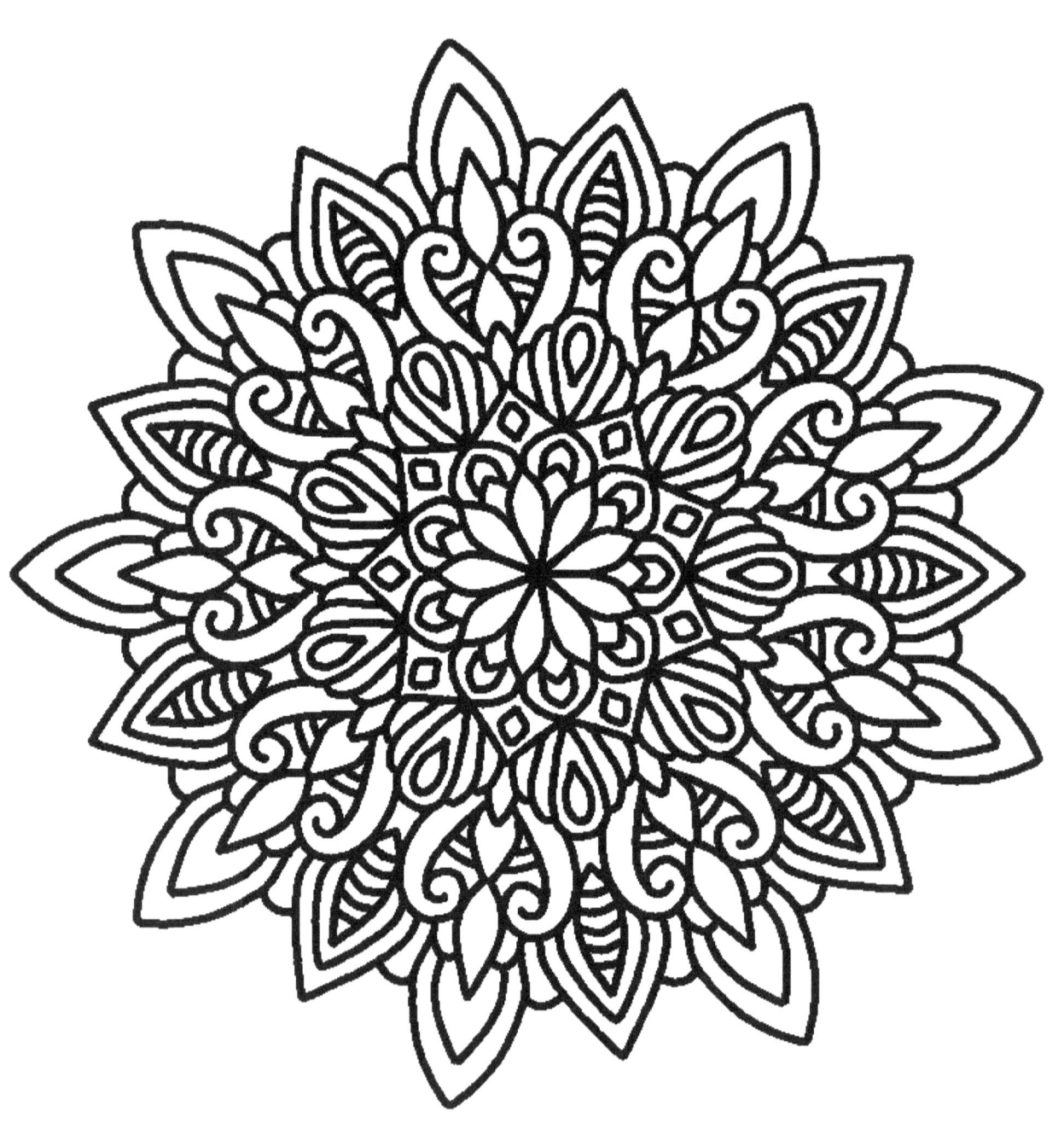

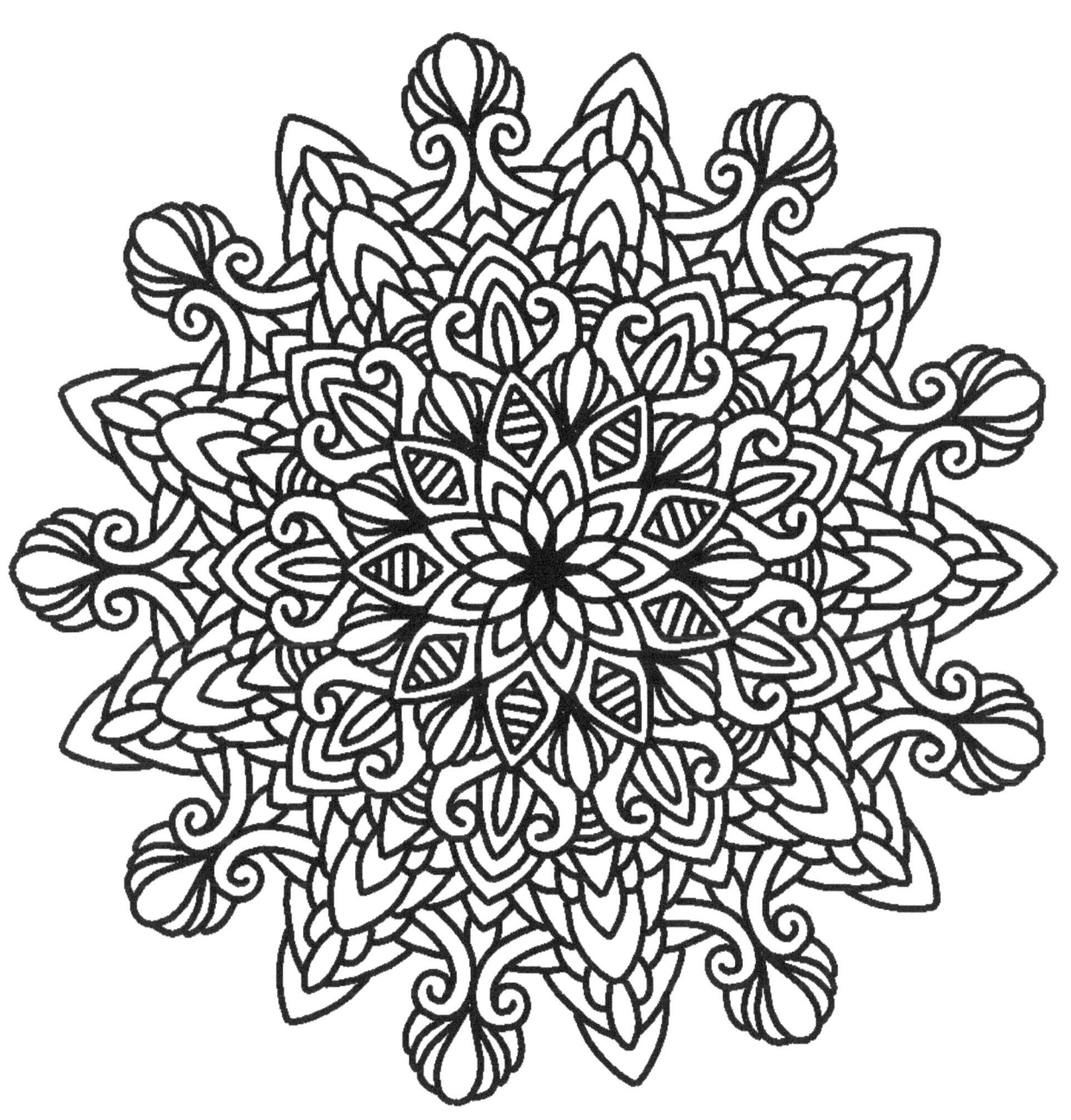

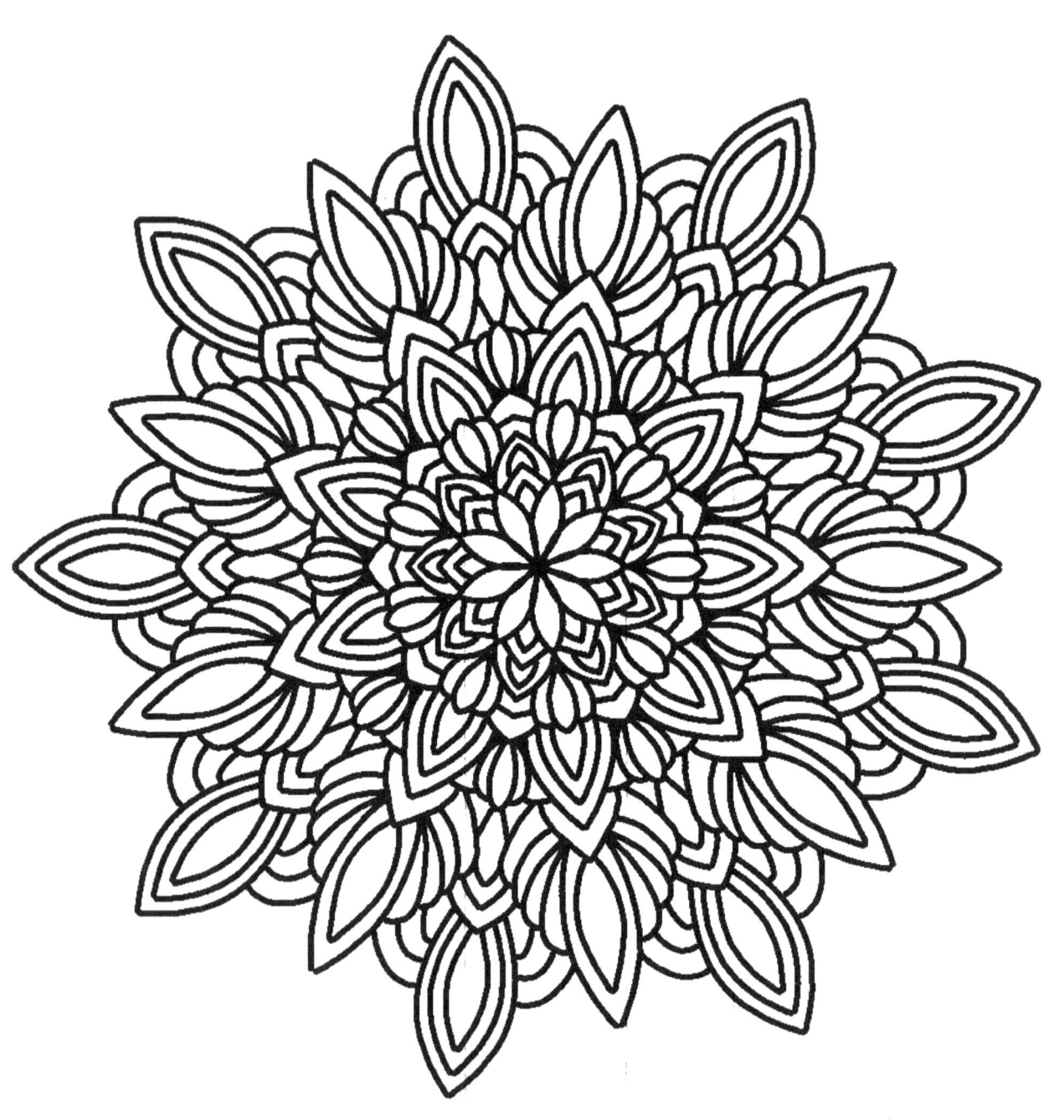

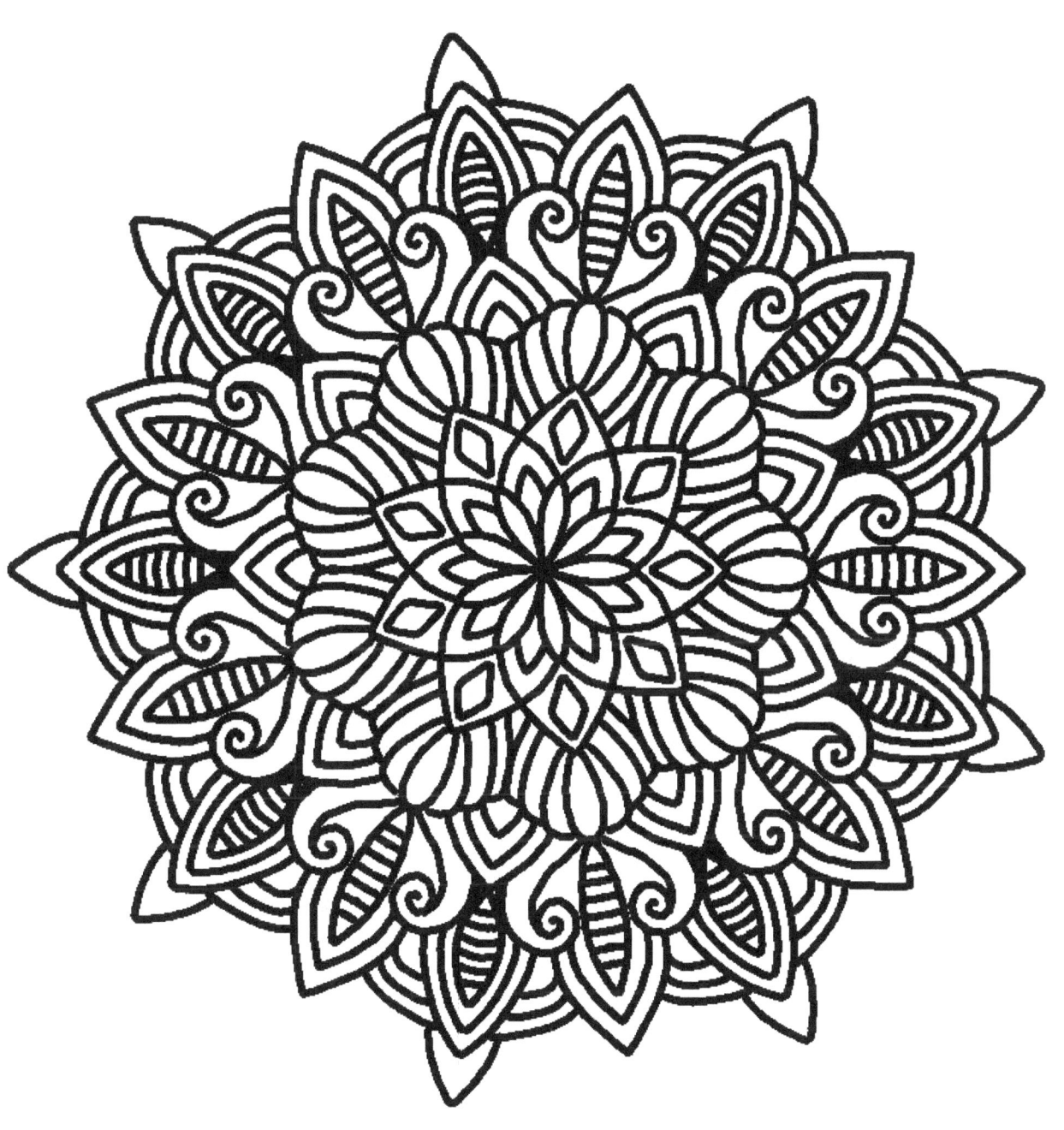

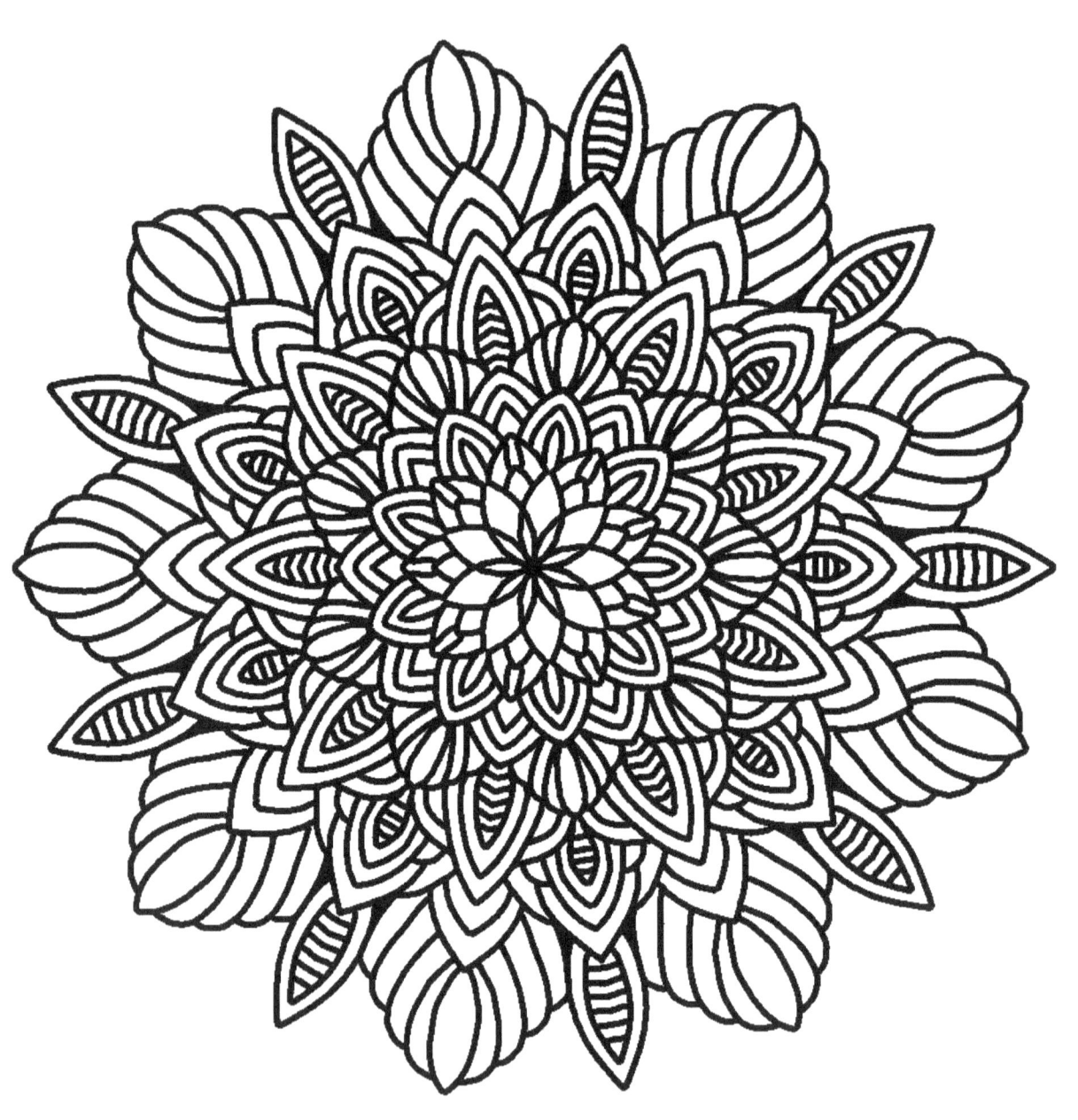

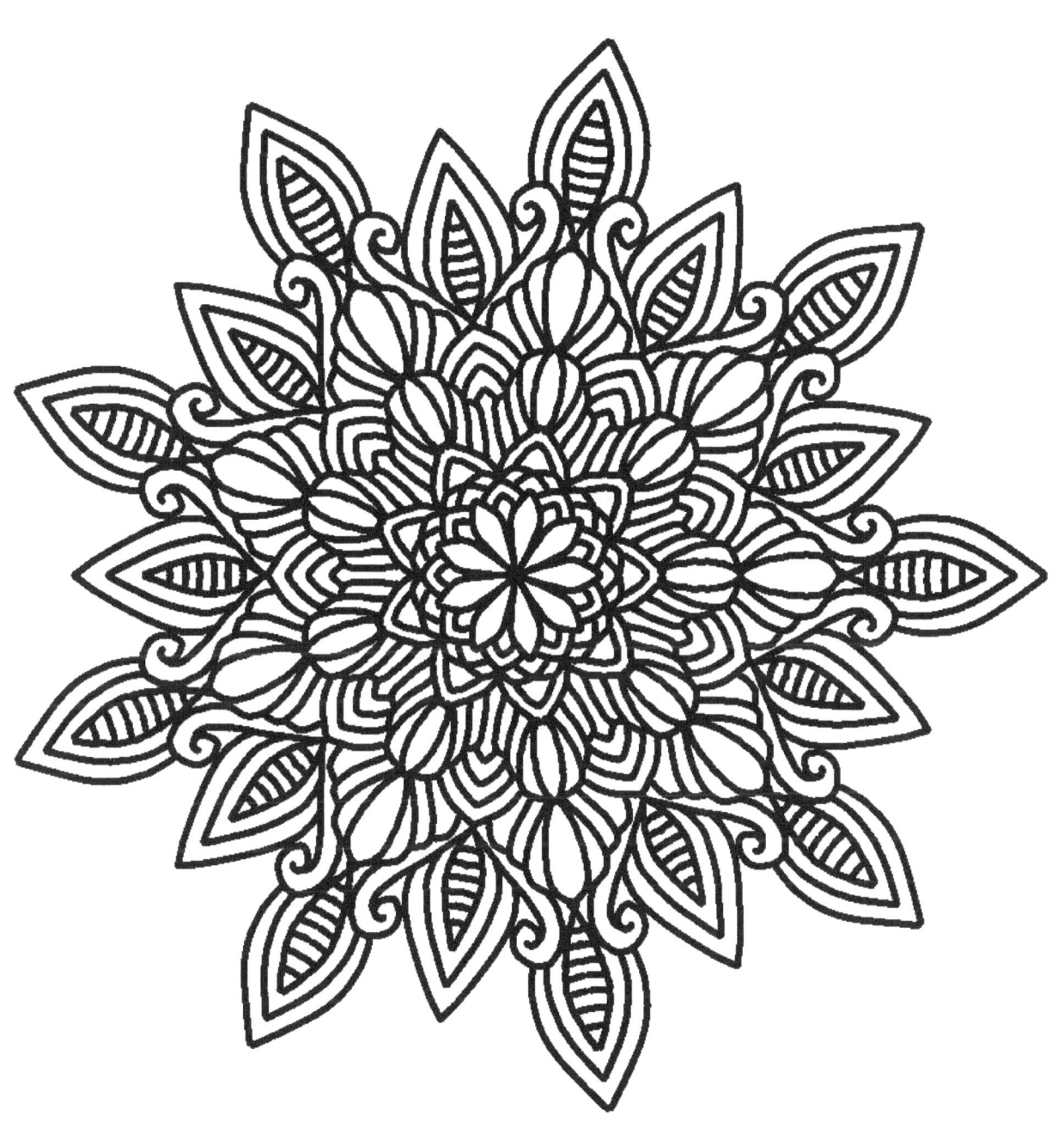

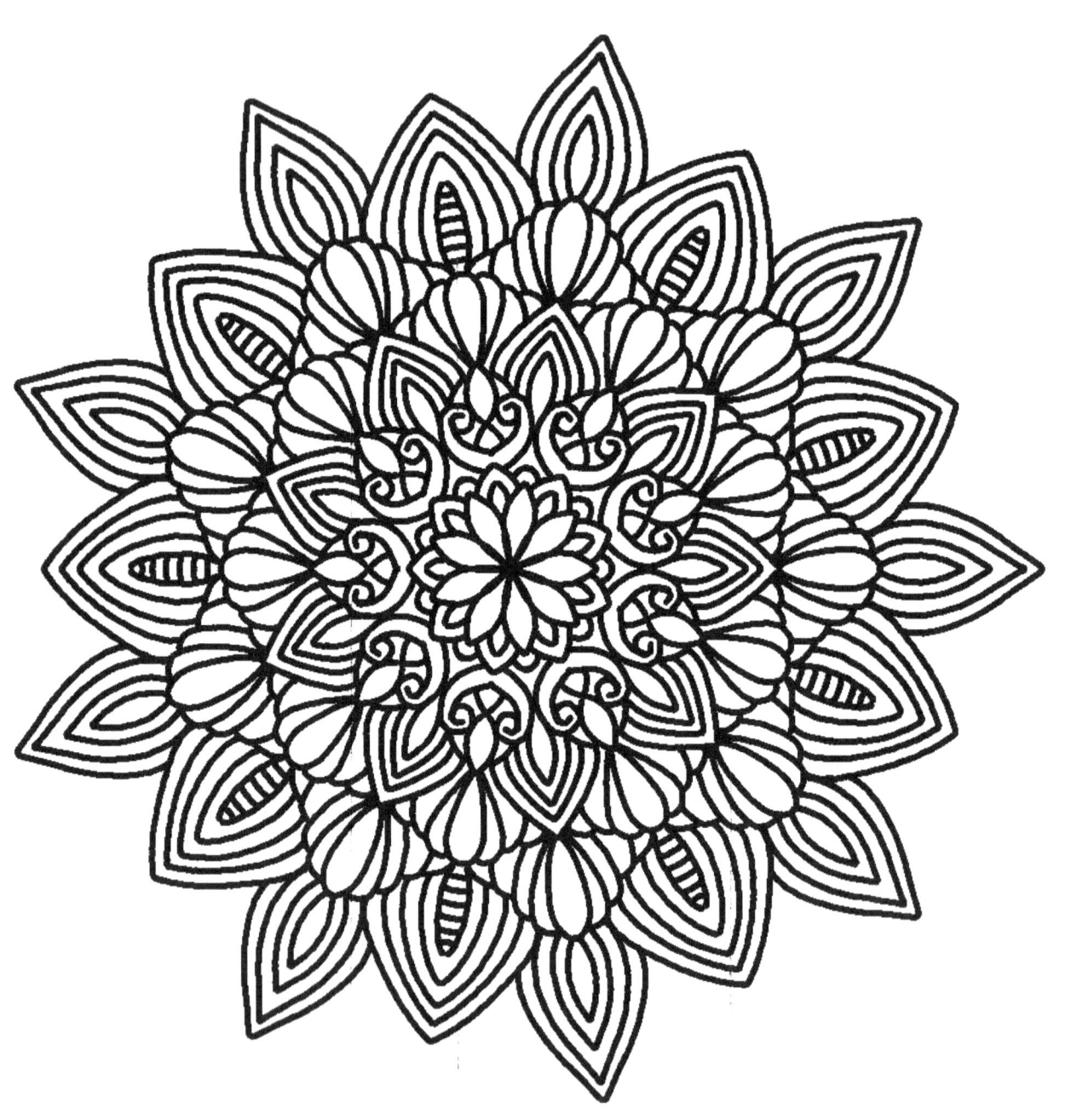

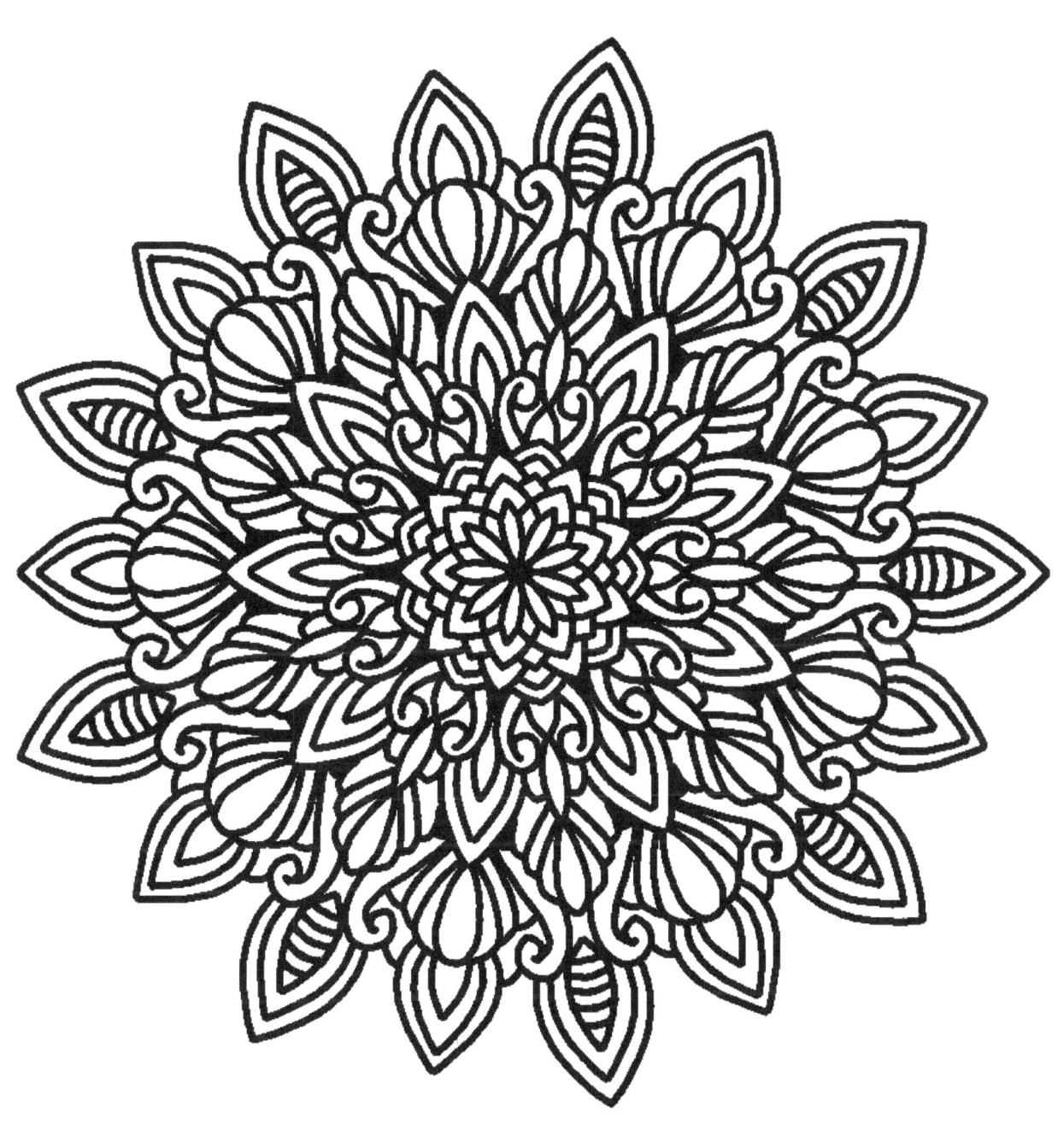

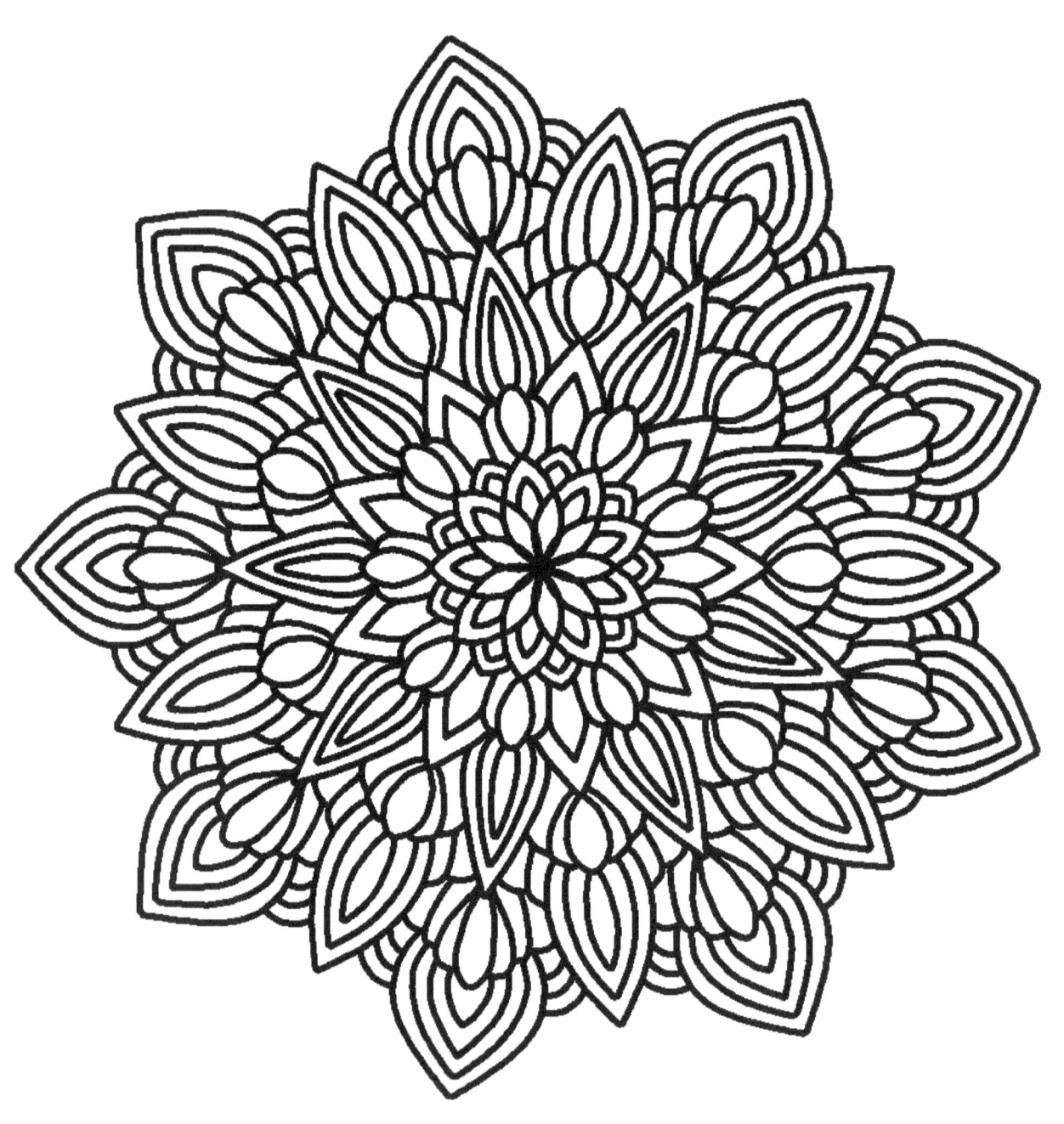

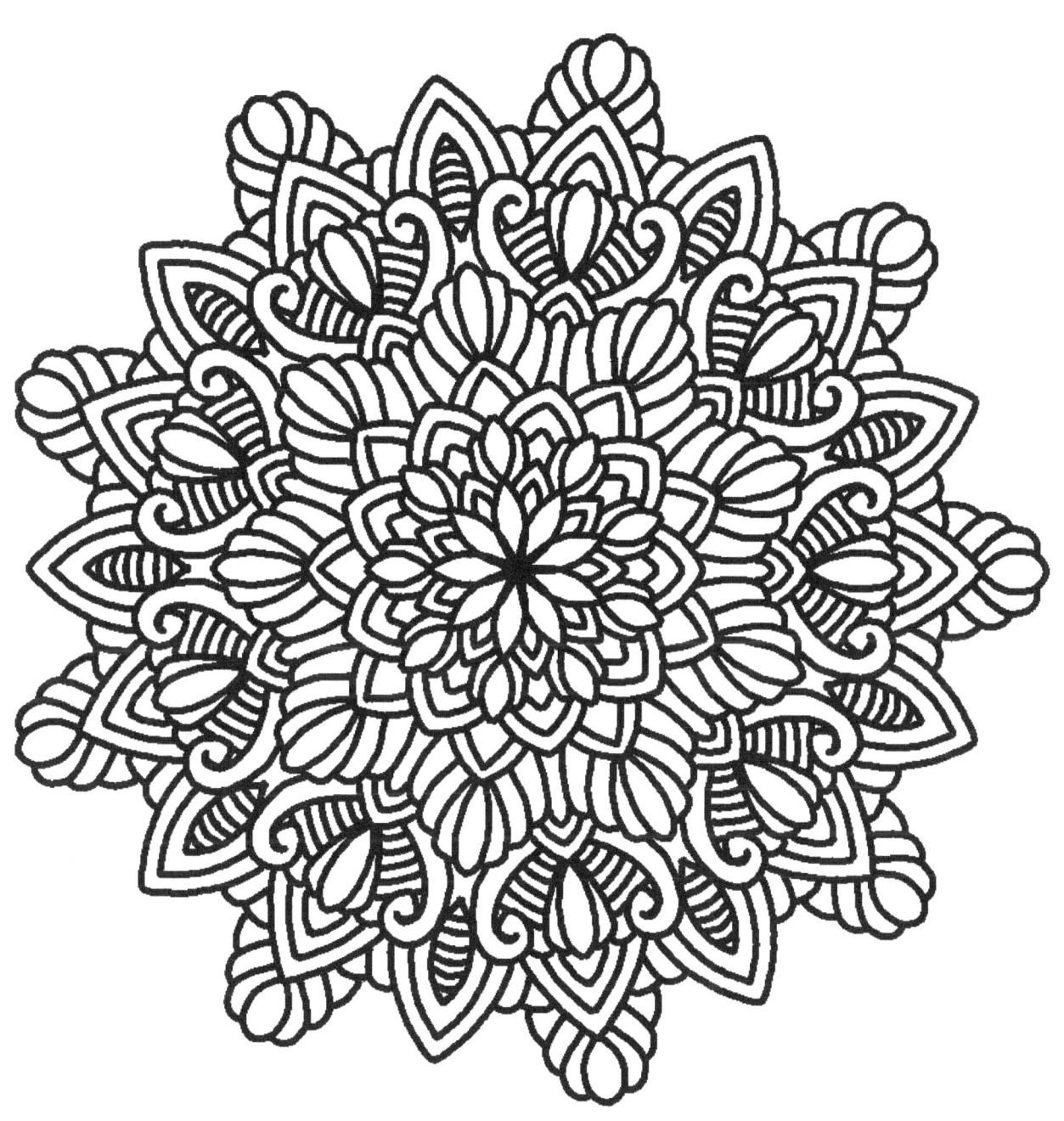

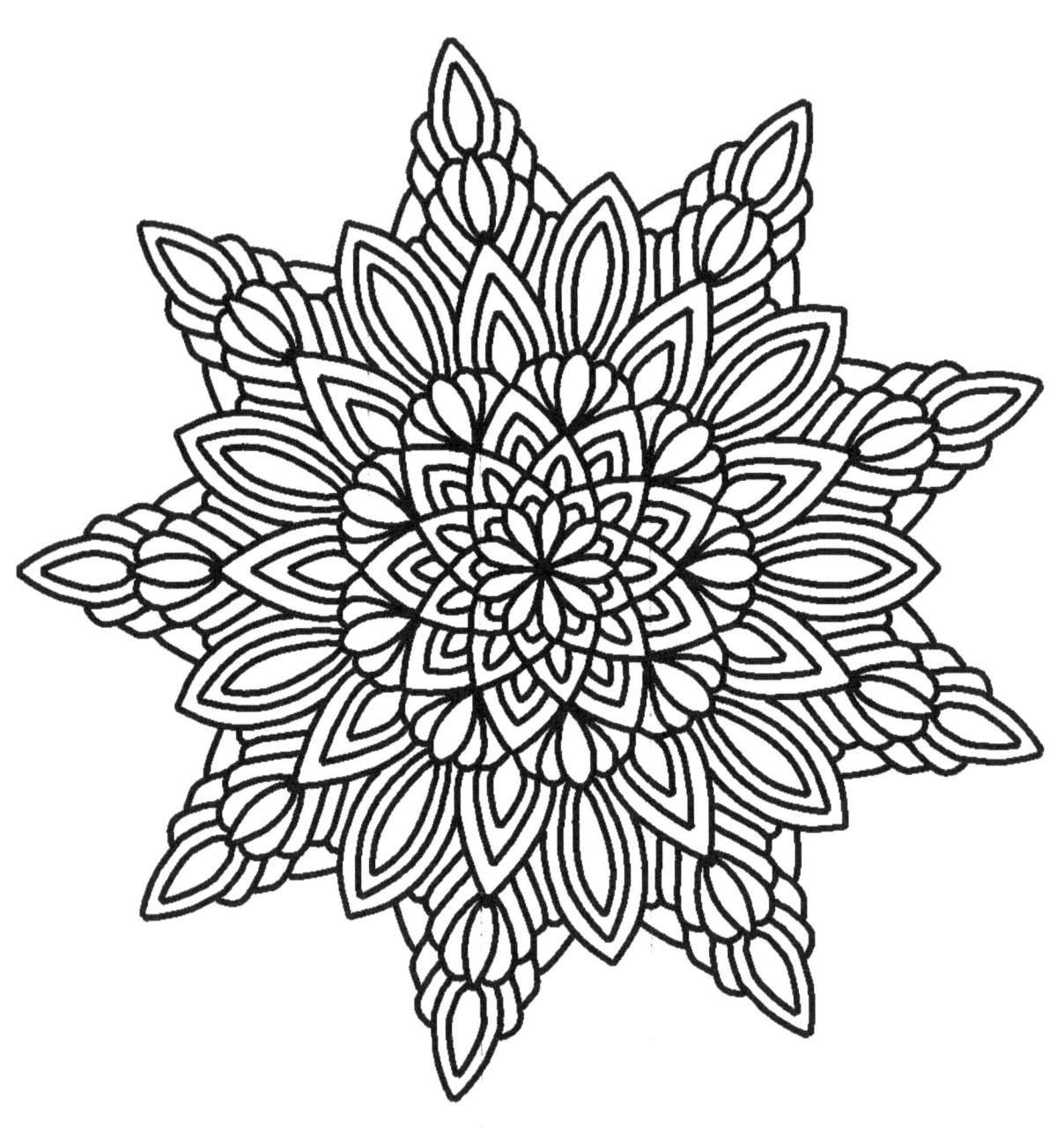

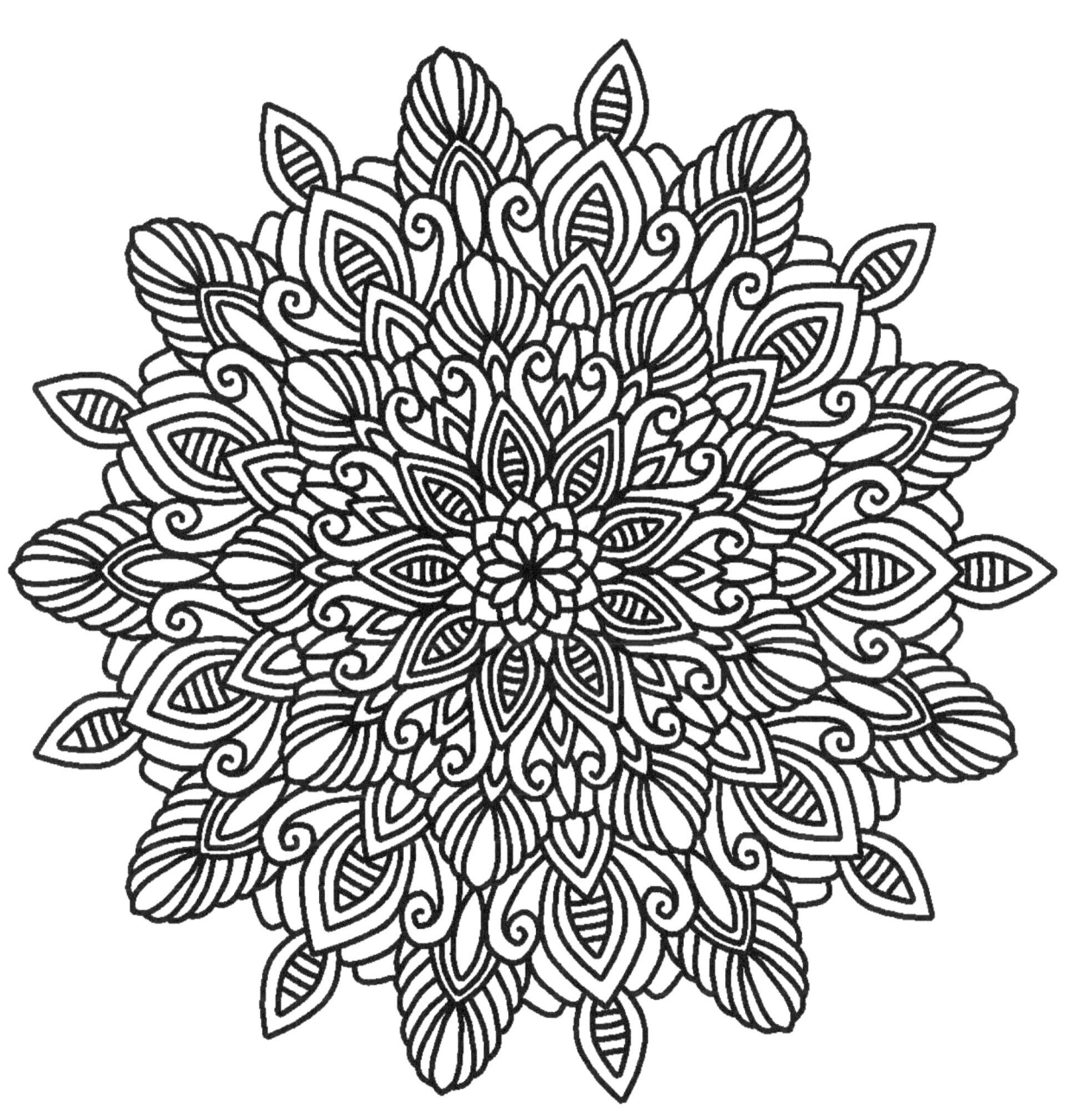

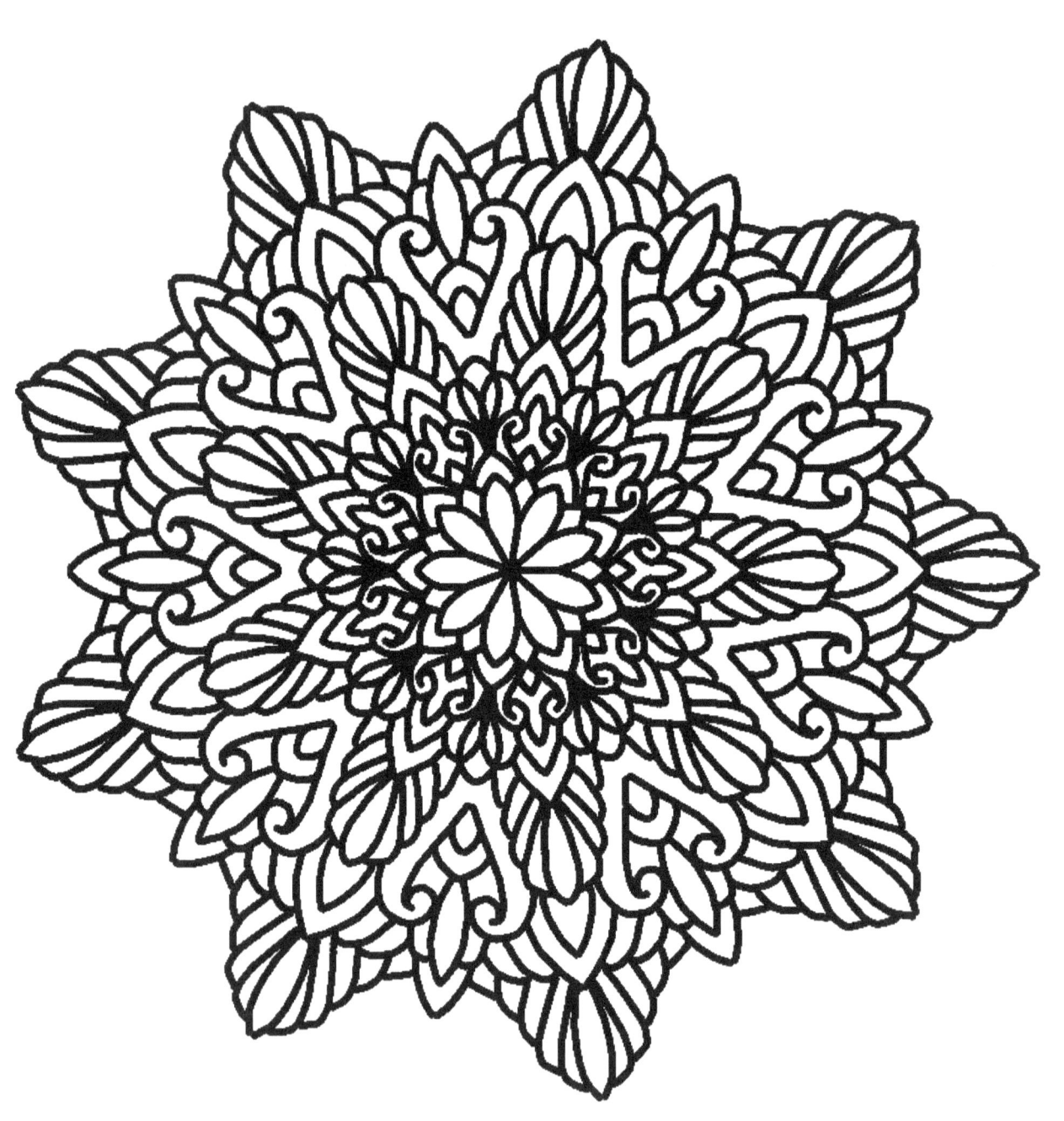

THE END.

www.ingramcontent.com/pod-product-compliance
Lightning Source LLC
Chambersburg PA
CBHW080709190526
45169CB00006B/2301